DESIGN AND CRIME

DESIGN AND CRIME

AND OTHER DIATRIBES

HAL FOSTER

VERSO

London • New York

First published by Verso 2002
© Hal Foster 2002
Paperback edition first published by Verso 2003
© Hal Foster 2003

1 3 5 7 9 10 8 6 4 2

Verso
UK: 6 Meard Street, London W1F 0EG
USA: 180 Varick Street, New York, NY 10014–4606
www.versobooks.com

Verso is the imprint of New Left Books

ISBN 1–85984–453–7

British Library Cataloguing in Publication Data
Foster, Hal
 Design and crime : and other diatribes
 1. Culture 2. Design 3. Architecture and society
 I. Title
 306.4′

ISBN 1859844537

Library of Congress Cataloging-in-Publication Data
A catalog record for this book is available from the Library of Congress

Typeset by SetSystems Ltd, Saffron Walden, Essex
Printed and bound in the UK by The Bath Press, Avon

What is critical consciousness at bottom if not an unstoppable predilection for alternatives?

Edward Said

CONTENTS

LIST OF ILLUSTRATIONS
AND CREDITS

We gratefully acknowledge an illustrations subsidy from the Publications Committee, Department of Art and Archaeology, Princeton University.

PREFACE

This book is a polemical account of recent changes in the cultural status of architecture and design as well as art and criticism in the West. Part I, which focuses on architecture and design, is made up of brief reports. Chapter 1 surveys the merging of marketing and culture, while Chapter 2 considers the penetration of design in everyday life. Chapters 3 and 4 are case-studies of two signal careers in architecture: the first examines the building of Frank Gehry in a world of heightened spectacle, while the second reviews the writing of Rem Koolhaas on mutations in the global city.

Part II shifts the focus to disciplines and institutions. In Chapter 5 I trace the discursive relations between modern art and modern museum as seen by writers from Baudelaire and Valéry to the present. Chapter 6 explores the conceptual vicissitudes of art history in the late nineteenth century and visual studies in the late twentieth century. In Chapter 7 I recount the recent travails of art criticism in the United States, with the rise and fall of different methods and models. And Chapter 8 describes the various strategies of living-on in the double aftermath of modernism and postmodernism.

Certain themes recur in Part I, such as the branding of identity and the prevalence of design, the advance of spectacle and the

ideology of information. With the spread of a post-Fordist economy of tweaked commodities and niched markets, we experience an almost seamless circuit of production and consumption. Display has become ever more prominent in this order, and architecture and design all-important. In the process some of our cherished ideas of critical culture seem weakened, even emptied out. To what extent has "the constructed subject" of postmodernism become "the designed subject" of consumerism? To what extent has the expanded field of postwar art become the administered space of contemporary design?

My title echoes a famous diatribe of a hundred years ago by the architect Adolf Loos, who in "Ornament and Crime" (1908) attacked the indiscriminate spread of ornament in all things. Yet the point was not to claim an "essence" or "autonomy" of architecture or art; rather, as his friend Karl Kraus insisted, it was to carve out the space necessary for any practice to develop, "to provide culture with running-room." I think we need to recapture some sense of the political situatedness of artistic autonomy and its transgression, some sense of the historical dialectic of critical disciplinarity and its contestation – to attempt again to provide culture with running-room.

If architecture and design have a new prominence in culture, art and criticism appear less important, and there are no strong paradigms to guide them. For many people this is a good thing: it promotes cultural diversity. That may be, but it can also abet a flat incommensurability or a dismal indifference. Part II traces the prehistory of this contemporary version of "the end of art." In Chapters 5 and 6 I describe a dialectic of reification and reanimation in the construction of modern art and modern museum alike. The penultimate chapter recounts the demise of a dominant formation of postwar artist and critic, but the final chapter cautions against

any premature report of the death of art and criticism as such. Throughout the book I try to relate cultural and discursive forms to social and technological forces, and to periodize them in a way that points to political differences today. That is my principal aim: to point to critical possibilities in the present, and to promote "the unstoppable predilection for alternatives."

<center>∗</center>

Early versions of Chapters 1–4 appeared in *London Review of Books*, and I thank its editors, especially Mary-Kay Wilmers and Paul Laity, for support. Ditto the editors of *New Left Review*, where a first version of Chapter 7 appeared, as well as my sponsors at Verso, Perry Anderson and Tariq Ali: their encouragement has meant a lot to me, as has the assistance of editor Tim Clark and Gavin Everall.[1] This book was aided by a Guggenheim fellowship, for which I am grateful. As usual I thank friends at *October* and *Zone*, especially Benjamin Buchloh, Denis Hollier, Rosalind Krauss, Michel Feher, and Jonathan Crary. I am also grateful to colleagues at Princeton not only in my department but in others as well, such as Eduardo Cadava, Beatriz Colomina, Alan Colquhoun, Andrew Golden, Anthony Grafton, Michael Jennings, Stephen Kotkin, Thomas Levin, Alexander Nehamas, Anson Rabinbach, Carl Schorske, and Michael Wood. Thanks too to supportive and superegoic voices elsewhere, particularly Emily Apter, Ron Clark, T. J. Clark, Kenneth Frampton, Silvia Kolbowski, Greil Marcus, Jenny Marcus, Anthony Vidler, and Anne Wagner. Other friends have supported me, as has my family (Sandy, Tait, and Thatcher), in ways impossible to describe here. Finally, this book is dedicated to my siblings (Jody, Andy, and Becca) and my nieces (Erin, Jovita, and Zoë), who know a good diatribe when they hear one.

PART I
ARCHITECTURE AND DESIGN

ONE

BROW BEATEN

Oppositions of high and low, elite and popular, modernist and mass, have long structured debates about modern culture. They have become second nature to us, whether we want to uphold the old hierarchies, critique them, or somehow overthrow them. They always have borne on matters of class; indeed there is one system of distinctions – highbrow, middlebrow, and lowbrow – that explicitly refers differences of culture to differences of class (both of which are understood in a pseudo-biological way). Yet what if this brow system has undergone a lobotomy before our very eyes?

This is the proposition of *Nobrow: The Culture of Marketing, the Marketing of Culture* by John Seabrook, a critic-at-large for *The New Yorker*, who takes the recent history of this once-middlebrow magazine as the prime test-case of his postmodern thesis.[1] For

Seabrook this "nobrow" state – where the old brow distinctions no longer seem to apply – is not only a dumbing down of intellectual culture; it is also a wising up to commercial culture, which is no longer seen as an object of disdain but as "a source of status." At the same time this child of the elite is ambivalent about the collapse of brow distinctions, caught as he is between the old world of middlebrow taste, as vetted by *The New Yorker* of yore, and the new world of nobrow taste, where culture and marketing are one. Born to the "Townhouse" of the former ("taste was my cultural capital, boiled down to a syrup"), Seabrook now wanders in the "Megastore" of the latter. And yet this desert is not so arid to him: he drinks more deeply at the oases of nobrow culture than he does in the gardens of elite culture (e.g., "interesting plays, the Rothko show, the opera, and, sometimes, downtown happenings").

On one level *Nobrow* is the story of his awakening to nobrow culture. On another, it is an insider account of *The New Yorker* as it struggles to find a place in "the Buzz" of this culture after decades in which its status was secured by its indifference to that Buzz. Its old formula for financial success was its middlebrow mediation of high culture and refusal of low culture – a formula that attracted ambitious readers and advertisers in droves. According to Seabrook, this formula began to fail by the middle Reagan–Thatcher years, that is, at a time when corporate merging and culture marketing expanded exponentially. The search for a place in the Buzz was also important for Seabrook: he too had to find some orientation in it, some purchase on it – not only as another citizen–consumer in the Megastore who "samples" his signs of identity from its offerings, but also as a journalist–critic who needed to be familiar enough with it to report on it. *Nobrow* is framed by a first chapter that sets out this double quest of *The New Yorker* and Seabrook to find a

place in the Buzz and a final chapter that reports on the mixed results of both to do so.[2]

According to Seabrook, the old *New Yorker* was "almost perfectly in synch" with a social system in which the commercial advance of one generation was sublimated by the cultural advance of the next. This advance was certified by signs of taste, which is also to say by displays of "distaste for the cheap amusements and common spectacles that make up the mass culture." *The New Yorker* was able to teach this dis/taste without too much bitterness, and – here was the magic, or the ruse, of the magazine – this offer appealed to a good portion of the very masses that were disdained by it. *The New Yorker* also had the ace of Manhattan in its hand. Like Saks Fifth Avenue or Brooks Brothers, it parlayed a regional cachet into a national reputation for quality, which translated into a national market for consumption: to keep above the sea of the middle class, you had to shop at Saks Fifth Avenue or Brooks Brothers, had to stay up with cultural affairs (to be chicly in-the-know) through *The New Yorker*. This distinction was the commodity on sale, and it sold well to affluent suburbanites from Syracuse to Seattle whose coffee-tables were adorned by the magazine.

But then came the merging and the marketing, the financing and the franchising. Suddenly there was a Saks or a Brooks in your hometown too, and you no longer had to go to Manhattan, physically or vicariously via *The New Yorker*, to appear metropolitan; you could get it at the mall – and now at the website.[3] Like Saks or Brooks, *The New Yorker* was forced to find its niche in the Megastore. Once indifferent to the Buzz, *The New Yorker* had become irrelevant to it, and so irrelevant *tout court*. It no longer worked, culturally or financially, to be either snooty or campy about lowbrow culture; at the same time its mediation of highbrow culture no longer counted for much either. "*The New Yorker* was one of the

last of the great middlebrow magazines, but the middle had vanished in the Buzz, and with it had gone whatever status being in the middle would get you."

Yet, finally, who really cares about *The New Yorker*? It has condescended to its suburbanite subscribers for so long that they must begrudge it deep down, and many of the residents of the city (who know it at all) resent it outright – for the arrogation of *its* New York as *the* New York, among other crimes (who are those people in those cartoons at those cocktail parties anyway?). Luckily, the interest of *Nobrow* lies elsewhere, not in its gossipy account of a gossipy magazine, but in the pop ethnography developed by Seabrook out of his encounters with several "arbiters of culture in Nobrow." Since this culture is dominated by entertainment industries, these arbiters are mostly "creative heads" of music and movie businesses. And so we eavesdrop on Judy McGrath, president of MTV, as she attempts, across divides of race, gender, and class, to connect with gangsta rappers like Snoop Doggy Dogg, with the knowledge that hiphop is primarily what keeps the Buzz in her business. We watch as Danny Goldberg, head of Mercury Records, tests the vibe on a fourteen-year-old kid from Dallas, touted as "the next Kurt Cobain" (his group "Radish" did not pan out, as "Hansen" took up the teen-rock slot). We spy on George Lucas at his 3000-acre Skywalker Ranch in northern California as "the great artist of Nobrow," too busy for filmmaking, oversees the retailing of his *Star Wars* brand. (Seabrook begins this chapter: "I go to the supermarket to buy milk, and I see *Stars Wars* has taken over aisle 5, the dairy section.") And we listen to the musings of David Geffen, the music and movie mogul that Seabrook locates at the summit of "High Nobrow": "He had a mind so fine that no idea of hierarchy could penetrate it" (apparently nobrow has distinctions of its own). Again, the interest of the book is in these field reports, but it also

lies in the self-analysis performed by Seabrook as he attempts to graph this "tectonic shift" in culture on the fly.

<div align="center">∗</div>

What are the bearings that this "hegemonculus" takes (this is his funny-awful hybrid of "hegemony" and "homunculus")? Again, the old map of oppositions – high and low culture, modernist and mass art, uptown and downtown scenes – no longer works for Seabrook, so he revises it somewhat, with a new legend to go along with it, the lexicon that I have adopted here: Nobrow (where "commercial culture is a source of status," not of disdain); the Buzz ("a shapeless substance into which politics and gossip, art and pornography, virtue and money, the fame of heroes and the celebrity of murderers, all bleed"); Townhouse and Megastore ("in the townhouse there was content and advertising; in the megastore there was both at once"); Small-grid and Big-grid ("the America of you and me" and "the America of 200 million"; "what lies between is a void"). In the end, as Seabrook sees it, the law of Nobrow is simple: the Matthew Arnold criterion of the-best-that-is-thought-and-written is long gone, and the Buzz principle of whatever-is-hot rules. No more "Is it good?" or even "Is it original?", only "Does it work in the demo?" – "demo" as in demographics, not to be confused with democracy, much less demonstration. (For Seabrook, Clinton was "the perfect steward" of this "numbers-and-spin construct" of "polls, focus groups and other forms of market research." He was, after all, the first president to appear on MTV – but George W has begun to learn his lines as well.)

 What are the findings that Seabrook makes? Not surprisingly, they boil down to hypotheses about identity and class. "Once quality is deposed," he argues, identity is "the only shared standard of judgment." For Seabrook this identity must be "authentic," and it

can only be made so in nobrow culture through a personal sampling of pop goods at the Megastore: "Without pop culture to build your identity around, what have you got?" For an old guard of American highbrows like Dwight MacDonald and Clement Greenberg, this statement would be grotesque: mass culture is the realm of the inauthentic, and that is it. For Seabrook (and here he has learned from the academic discourse known as "cultural studies"), it is not absurd at all – in large part because he views pop culture not as mass culture but "as *folk* culture: our culture." Yet this semi-paradoxical turn of phrase does not solve a basic problem today: given his account of the Megastore, is the "sampling" of an identity à la hiphop clearly different from the "branding" of an identity à la George Lucas? British cultural studies gave us the notions of "subversive subcultures" and "resistance through rituals"; and American cultural studies elaborated the notion of a postmodernist subject that is culturally constructed, not naturally given. But with the near-instantaneous time-to-market from margin to Megastore (or from Small-grid to Big-grid), how much subversion or resistance can subcultures offer? And is the postmodernist constructed subject so different from the postindustrial consumerist subject – that "perfect hybrid of culture and marketing," as Seabrook calls it, "something to be that was also something to buy"? This is one of several recoupings of recent positions in cultural studes that Sea-brook implies: call it The Revenge of the Hegemonculus.

His next finding (which is also his next recouping) concerns class. "No one wants to talk about social class – it's in poor taste, even among the rich – so people use cultural distinctions instead." This is true enough, if we grant Seabrook the typical *New Yorker* conflation of his social world with the United States at large. But then he continues with more than a touch of class nostalgia: "As long as this system of distinctions existed, it permitted considerable

equality among the classes." Here his former editor at *The New Yorker*, the Brit Tina Brown, knows better than he: with her formation in a country where class is not quite so mystified, she sees the hierarchy of taste as nothing but a hierarchy of power "that used taste to cloak its real agenda." Seabrook takes her point, but when he argues that the old cultural distinctions are undone in nobrow, he offers a further cloak, all the more deceptive because it seems to be no disguise at all. That is, he implies that class divisions have disappeared along with cultural distinctions: we are all in the Megastore now, Seabrook claims, only sometimes in different aisles, with different samples in our identikits. This is a second revenge on cultural studies – of the sort that argues that culture and economy are now one – and perversely it transforms this largely leftist argument into another end-of-class thesis, a thesis that (like the recent version of the end-of-history thesis) is predominantly neo-conservative. Although here Seabrook does know better, this hegemonculus sometimes sounds like a neocon.[4]

Perhaps this is the ultimate commodity on sale at the Megastore: the fantasy that class divisions are suspended. This fantasy serves as the contemporary complement to the foundational myth of the United States – that such divisions never existed in the first place. There are other magical resolutions on offer in nobrow as well. For example, Seabrook is aware of the fantasy of racial unity on sale in the Megastore (e.g., "Gangsta [rap] had become merely a more real blues for jaded palates like mine that required fresh fixes of social reality in pop form"). But he is not so clear about other magical resolutions on offer. In a chapter devoted to a visit home to his family farm in southern New Jersey, he takes on his father in a battle of clothes: his Chemical Brothers T-shirt emblazoned with DANACHT (hiphop for "the new shit") versus the Savile Row suits of Seabrook *père*. "My father used his clothes to pass along culture

to me. I, in turn, used clothes to resist his efforts." But Seabrook actually avoids the fight through generational cross-dressing: he dons one of the paternal suits for dinner the last night, to the mutual delight of parents and son. It seems that Oedipal tensions can also be eased, culturally, with the right clothes, the right style. Yet Seabrook misses his own point here: these tensions are eased because he slips into the elegant suit, appeases the father – because he upholds his class style (or pretends to do so – but is there a great difference?).

*

There is much in *Nobrow* to concede. For instance, there is another recouping – call it The Revenge on Postmodernism – that strikes me especially close to home. Among other things postmodernism was an attempt to open up art and culture to more practitioners and different audiences. But in the end, Seabrook implies, what was accomplished – the democratization of art and culture, or their annexation by nobrow? "Because more people could make art, more did. The market became flooded with art . . . The real and important artists had to compete for attention with every kid with a guitar and an interesting haircut." Again, one can dispute this account – it asks for it – but it has its grain of truth: "artist" has become too elastic a category, "art" too much a default term, as Seabrook captures in this remark: "Virtually everyone under twenty-five I met at MTV was an artist of one kind of another."

But there is much in the book to contest as well. First, there is the issue of class slipperiness, of slumming with rappers at the Roxy one night, and decanting fine wine with dad the next. Seabrook is hardly alone here, of course, and social ambiguity has proved to be a precondition of dandyish critics from Charles Baudelaire through Walter Benjamin and on down (see Chapter 4). Sometimes this

ambiguity translates into an ambivalence that leads Seabrook to insights about both worlds (rap and dad), but sometimes too it is about having it both ways (the Chemical Brothers T-shirt under the Savile Row suit). Moreover, this pragmatic ambivalence quickly shades into a cynical reason that Megastore marketers and Nobrow executives know how to play far better than Seabrook or any of the rest of us.

Second, Seabrook is one with the Buzz in a way that he might not want to be. In this time of dot.capitalism (however corrected by the market of late), if you can't make a brandname or a buzzword stick you don't exist for long; this is a contemporary version of the "fifteen minutes" of fame promised by Andy Warhol. And in this business of "branding," the culture of marketing and its criticism are not so dissimilar (more on which in Chapter 2). Seabrook implies as much when he drops the copyright sign in the title *Nobrow*, as if this term might have commercial legs to match "preppie," "yuppie," and the other conceits that have entered American lingo. In this regard, too, he sometimes misses the moral of his own Buzz studies: that the Buzz is a big bug-zapper. "You could feed the Buzz, and it fed you, too. But the Buzz was never satisfied." If Fashion was sometimes called Mister Death, the Buzz is an even grimmer reaper; that is part of its deadly charge that Seabrook mistakes for hip *frisson*.

Third, how new is all of this? Is there a "tectonic shift" in the relation between culture and marketing, a merging of the two, or is the Megastore just another version of "the culture industry" critiqued long ago by Max Horkheimer and Theodor Adorno?[5] One can periodize three phases of this industry in the twentieth century: the first in the 1920s as radio spread, sound was connected to film, and mechanical reproduction became pervasive (Guy Debord dated the birth of "spectacle" to this moment); the second in the postwar

production of consumer society, the image world of commodities and celebrities screened by Warhol and others; and a third in our own midst, the digital revolution and dot.capitalism.[6] Like many of us in this moment of massive retooling and retraining, Seabrook may mistake signs for wonders.

Finally, is nobrow culture as total as he makes it out to be? One chapter is a bravura tour of stores in downtown Manhattan, where Seabrook finds essentially the same black T-shirt at vastly different prices. But even SoHo on Sunday is not as homogeneous as he suggests here, and the city is not so bereft of *dérives* even today. Strange though it may sound for an academic to say, Seabrook needs to get around more; his fieldwork does not go far enough afield. For all his ironic insights about his profiled subjects, they define the world too much for him; that is a high-corporate view, not a nobrow one. However politically correct it may sound, it is good to counter the wondrous statistics issued from the Megastore – like the fact that in the year 2000 there were ten million households with $100,000-plus incomes in the US alone – with a reality-check list from somewhere else – like the fact that half of the people on this planet have never used a telephone.

TWO

DESIGN AND CRIME

The turn of one century calls up others, and 2000 was no exception. Over the last few years *Style 1900* or Art Nouveau has returned with a vengeance in museum shows and academic books. It all seems long ago and far away, this pan-European movement pledged to a *Gesamtkunstwerk* or "total work" of arts and crafts, in which everything from architecture to ashtrays was subject to a florid kind of decoration, in which the designer struggled to impress his subjectivity on all sorts of objects through an idiom of vitalist line – as if to inhabit the thing in this crafted way was to resist the advance of industrial reification somehow. As the aesthetics of the machine became dominant in the 1920s, Art Nouveau was no longer *nouveau*, and in the next decades it slowly passed from an outmoded style to a campy one, and it has lingered in this limbo ever since. Yet what struck me, in the midst of this recent parade of Art Nouveau

manifestations, was its strong echo in the present – an intuition that we live in another era of blurred disciplines, of objects treated as mini-subjects, of total design, of a *Style 2000*.

Adolf Loos, the Viennese architect of austere façades, was the great critic of the aesthetic hybridity of Art Nouveau. In his milieu he was to architecture what Schönberg was to music, Wittgenstein to philosophy, or Karl Kraus to journalism – a scourge of the impure and the superfluous in his own discipline. In this regard "Ornament and Crime" (1908) is his fiercest polemic, for there he associates the Art Nouveau designer with a child smearing walls and a "Papuan" tattooing skin. For Loos the ornate design of Art Nouveau is erotic and degenerate, a reversal of the proper path of civilization to sublimate, to distinguish, and to purify: thus his notorious formula – "the evolution of culture is synonymous with the removal of ornament from utilitarian objects" – and his infamous association of "ornament and crime."[1] This anti-decorative dictate is a modernist mantra if ever there was one, and it is for the puritanical propriety inscribed in such words that postmodernists have condemned modernists like Loos in turn. But maybe times have changed again; maybe we are in a moment when distinctions between practices might be reclaimed or remade – without the ideological baggage of purity and propriety attached.

Loos began his battle with Art Nouveau a decade before "Ornament and Crime." A pointed attack comes in 1900, in the form of an allegorical skit about "a poor little rich man" who commissions an Art Nouveau designer to put "Art in each and every thing":

Each room formed a symphony of colors, complete in itself. Walls, wall coverings, furniture, and materials were made to

harmonize in the most artful ways. Each household item had its own specific place and was integrated with the others in the most wonderful combinations. The architect has forgotten nothing, absolutely nothing. Cigar ashtrays, cutlery, light switches – everything, everything was made by him.[2]

This *Gesamtkunstwerk* does more than combine architecture, art, and craft; it commingles subject and object: "the individuality of the owner was expressed in every ornament, every form, every nail." For the Art Nouveau designer this is perfection: "You are complete!" he exults to the owner. But the owner is not so sure: this completion "taxed [his] brain." Rather than a sanctuary from modern stress, his Art Nouveau interior is another expression of it: "The happy man suddenly felt deeply, deeply unhappy . . . He was precluded from all future living and striving, developing and desiring. He thought, this is what it means to learn to go about life with one's own corpse. Yes indeed. He is finished. *He is complete!*"

For the Art Nouveau designer this completion reunites art and life, and all signs of death are banished. For Loos, on the other hand, this triumphant overcoming of limits is a catastrophic loss of the same – the loss of the objective constraints required to define any "future living and striving, developing and desiring." Far from a transcendence of death, this loss of finitude is a death-in-life, as figured in the ultimate trope of indistinction, living "with one's own corpse."

Such is the malaise of "the poor little rich man": rather than a man of qualities, he is a man without them (as another Viennese scourge, the great novelist Robert Musil, would soon put it), for what he lacks, in his very completion, is difference or distinction. In a typically pithy statement of 1912 Kraus would call this lack of distinction, which precludes "all future living and striving," a lack of "running-room":

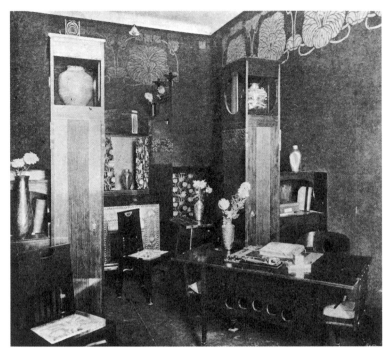

Josef Hoffmann, an Art Nouveau interior, 1899: "The individuality of the owner expressed in every ornament . . . this is what it means to go about life living with one's own corpse" (Adolf Loos).

Adolf Loos and I – he literally and I linguistically – have done nothing more than show that there is a distinction between an urn and a chamber pot and that it is this distinction above all that provides culture with running-room [*Spielraum*]. The others, the positive ones [i.e., those who fail to make this distinction], are divided into those who use the urn as a chamber pot and those who use the chamber pot as an urn.[3]

Here "those who use the urn as a chamber pot" are Art Nouveau designers who want to infuse art (the urn) into the utilitarian object (the chamber pot). Those who do the reverse are functionalist modernists who want to elevate the utilitarian object into art. (A few years later Marcel Duchamp would trump both sides with his dysfunctional urinal, *Fountain*, presented as art, but that's another story.) For Kraus the two mistakes are symmetrical – both confuse use-value and art-value – and both are perverse inasmuch as both risk a regressive indistinction of things: they fail to see that objective limits are necessary for "the running-room" that allows for the making of a liberal kind of subjectivity and culture. This is why Loos opposes not only the total design of Art Nouveau but also its wanton subjectivism ("individuality expressed in every nail"). Neither Loos nor Kraus says anything about a natural "essence" of art, or an absolute "autonomy" of culture; the stake is one of "distinctions" and "running-room," of proposed differences and provisional spaces.

<div align="center">*</div>

This old debate takes on a new resonance today, when the aesthetic and the utilitarian are not only conflated but all but subsumed in the commercial, and everything – not only architectural projects and art exhibitions but everything from jeans to genes – seems to be regarded as so much *design*. After the heyday of the Art Nouveau designer, one hero of modernism was the artist-as-engineer or the author-as-producer, but this figure was toppled in turn with the industrial order that supported it, and in our consumerist world the designer again rules. Yet this new designer is very different from the old: the Art Nouveau designer resisted the effects of industry, even as he also sought, in the words of Walter Benjamin, "to win back [its] forms" – modern concrete, cast iron, and the like – for

architecture and art.[4] There is no such resistance in contemporary design: it delights in postindustrial technologies, and it is happy to sacrifice the semi-autonomy of architecture and art to the manipulations of design. Moreover, the rule of the designer is even broader than before: it ranges across very different enterprises (from Martha Stewart to Microsoft), and it penetrates various social groups. For today you don't have to be filthy rich to be projected not only as designer but as designed – whether the product in question is your home or your business, your sagging face (designer surgery) or your lagging personality (designer drugs), your historical memory (designer museums) or your DNA future (designer children). Might this "designed subject" be the unintended offspring of the "constructed subject" so vaunted in postmodern culture? One thing seems clear: just when you thought the consumerist loop could get no tighter in its narcissistic logic, it did: design abets a near-perfect circuit of production and consumption, without much "running-room" for anything else.

Some may object that this world of total design is not new – that the conflation of the aesthetic and the utilitarian in the commercial goes back at least to the design program of the Bauhaus in the 1920s – and they would be right. If the first Industrial Revolution prepared the field of political economy, of a rational theory of material production, as Jean Baudrillard argued long ago, so the second Industrial Revolution, as styled by the Bauhaus, extended this "system of exchange value to the whole domain of signs, forms and objects ... in the name of design."[5] According to Baudrillard, the Bauhaus signaled a qualitative leap from a political economy of the product to a "political economy of the sign," in which the structures of the commodity and the sign refashioned one another, so that the two could circulate as one, as image-products with "sign exchange value," as they do in our own time.

Of course this is hardly what the Bauhaus Masters, some of whom were Marxists, had in mind, but such is often "the bad dream of modernism" in the ruses of history (as T. J. Clark once termed it). Beware of what you wish, runs one moral of modernism as seen from the present, because it may come true – in perverse form. Thus, to take only the chief example, the old project to reconnect Art and Life, endorsed in different ways by Art Nouveau, the Bauhaus, and many other movements, was eventually accomplished, but according to the spectacular dictates of the culture industry, not the liberatory ambitions of the avant-garde. And a primary form of this perverse reconciliation in our time is design.

So, yes, the world of total design is hardly new – imagined in Art Nouveau, it was retooled by the Bauhaus, and spread through institutional clones and commercial knock-offs ever since – but it only seems to be achieved in our own pan-capitalist present. Some of the reasons are not hard to find. Once upon a time in mass production, the commodity was its own ideology, the Model T its own advertising: its chief attraction lay in its abundant sameness. Soon this was not enough: the consumer had to be drawn in, and feedback factored into production (this is one origin-scene of modern design). As competition grew, special seductions had to be devised, and the package became almost as important as the product. (The subjectivizing of the commodity is already apparent in streamlined design and becomes evermore surreal thereafter; indeed Surrealism is quickly appropriated by advertising.) Our own time is witness to a qualitative leap in this history: with the "flexible specialization" of post-Fordist production, commodities can be continually tweaked and markets constantly niched, so that a product can be mass in quantity yet appear up-to-date, personal, and precise in address.[6] Desire is not only registered in products today, it is specified there: a self-interpellation of "hey, that's me"

greets the consumer in catalogues and on-line. This perpetual profiling of the commodity, of the mini-me, is one factor that drives the inflation of design. Yet what happens when this commodity-machine – now conveniently located out of the view of most of us – breaks down, as environments give out, markets crash, and/or sweat-shop workers scattered across the globe somehow refuse to go on?

Design is also inflated as the package all but replaces the product. Whether the design object is Young British Art or a Presidential candidate, "brand equity" – the branding of a product name on an attention-deficit public – is fundamental to many spheres of society, and hence design is too. Consumer-attention and image-retention are all the more important when the product is not an object at all. This became clear during the massive mergers of the Reagan–Thatcher years when new mega-corporations appeared to promote little else but their own new acronyms and logos.

Andreas Gursky, *Untitled V*, 1997: the perpetual profiling of the commodity, of the mini-me, drives the contemporary inflation of design.

Especially as the economy slumped under George I, this branding was a way to prop up stock value apart from the realities of productivity and profitability. More recently, the Internet has set a new premium on corporate name-recognition for its own sake. For dot.coms such brand equity is necessary for survival, and part of the recent purge of these virtual companies stemmed from a Darwinism of the web-name.

A third reason for the inflation of design is the increased centrality of media industries to the economy. This factor is obvious, so obvious that it might obscure a more fundamental development: the general "mediation" of the economy. I mean by this term more than "the culture of marketing" and "the marketing of culture"; I mean a retooling of the economy around digitizing and computing, in which the product is no longer thought of as an object to be produced so much as a datum to be manipulated – that is, to be designed and redesigned, consumed and reconsumed. This "mediation" also inflates design, to the point where it can no longer be

considered a secondary industry. Perhaps we should speak of a "political economy of design."

<p style="text-align:center">*</p>

Some of these speculations can be tested against *Life Style* by Bruce Mau, a compendium of projects by the Canadian designer who came to prominence with *Zone* Magazine and Books in the late 1980s. With a distinguished series of publications in classical and vanguard philosophy and history, this imprint is also known for "Bruce Mau Design," whose luscious covers with sumptuous images in saturated colors and layered pages with inventive fonts in cinematic sequencing have greatly influenced North American publishing. Sometimes Mau seems to design the publications to be scanned, and despite his frequent denials in *Life Style* he tends to treat the book as a design construct more than an intellectual medium.[7]

Life Style follows on the mammoth monograph of architectural projects by Rem Koolhaas, *S, M, L, XL* (1995), which Mau helped to design (these are not coffee-table books, they are coffee tables). With his usual wit Koolhaas picked this title to signal not only the various scales of his work – from domestic to urban – but also that hot architects are today like hot designers – they must have lines of merchandise to suit all customers (see Chapter 4). *Life Style* aspires to be the *S, M, L, XL* of design; it too is a massive manifesto-for-myself, a history of a design studio with an extravagant presentation of its projects, plus little credos, historical sketches, and laboratory studies about design, along with several anecdotes concerning Master Builders like Koolhaas, Frank Gehry, and Philip Johnson. Here too the title is a play on terms: we may hear "life style" as understood by Martha Stewart, but we are asked to think "life style" as conceived by Nietzsche or Michel Foucault – as an ethics of life, not a guide to décor. But the world surveyed by *Life Style* suggests

something else – a folding of the "examined life" into the "designed life." The book opens with a photograph of the planned Disney community "Celebration" captioned: "the question of 'life style,' of choosing how to live, encounters the regime of the logo and its images." This encounter is hardly a fair fight, and though Mau may identify with the underdog here, his design practice is contracted to the other side.

For *Life Style* is a success story: bigger and bigger clients – first academic and art institutions, then entertainment and other corporations – come to Mau in search of image design, that is to say, brand equity. Bruce Mau Design, he states candidly, "has become known for producing identity" and "channeling attention" for "business value." Fair enough, it is a business after all, but Mau should have left things there. "In this environment," he goes on, "the only way to build real equity is to add value: to wrap intelligence and culture around the product. The apparent product, the object attached to the transaction, is not the actual product at all. The real product has become culture and intelligence." They are eyed as so much design. So is history: commissioned to lay out a private museum of Coca-Cola memorabilia, Mau concludes, "Has America made Coke? Or, Has Coke made America?" Biological life is seen in these terms as well. "How does an entity declare itself within an environment?" You guessed it: design.

The remaking of space in the image of the commodity is a prime story of capitalist modernity as told by Georg Simmel, Siegfried Kracauer, Benjamin, the Situationists, and radical geographers since (e.g., David Harvey, Saskia Sassen). Today it has reached the point where not only commodity and sign appear as one, but often so do commodity and space: in actual and virtual malls the two are melded through design. Bruce Mau Design is in the vanguard here. Of one "identity program" for a Toronto bookstore chain,

Mau writes of a "retail environment . . . in which the brand iden-
tity, signage systems, interiors, and architecture would be totally
integrated." And of his graphic support for the new Seattle Public
Library designed by Koolhaas, he states: "The central proposition
involves erasing the boundaries between architecture and infor-
mation, the real and the virtual." This integration, that erasure, is
a deterritorializing of image and space that depends on a digitizing
of the photograph, its loosening from old referential ties (perhaps
the development of Photoshop will one day be seen as a world-
historical event), and on a computing of architecture, its loosening
from old structural principles (in architecture today almost any-
thing can be designed because almost anything can be built: hence
all the arbitrary curves and biomorphic blobs designed by Gehry
and followers – see Chapter 3). As Deleuze and Guattari, let alone
Marx, taught us long ago, this deterritorializing is the path of
capital.[8]

Mau develops the old insights into media of Marshall
McLuhan, but like his countryman he seems confused in his role
– is he a cultural critic, a futurist guru, or a corporate consultant?
In media futurology a critical term today can become a catchy
phrase tomorrow, and a cliché (or brand) the next. In a wry move
Koolhaas now copyrights his catchy phrases, as if to acknowledge
this commercial curdling of critical concepts on the page (see
Chapter 4). Yet for all the Situationist lingo of contemporary
designers like Mau, they don't "détourn" much; more than critics
of spectacle, they are its surfers (which is indeed a favorite figure
in their discourse), with "the status of the artist [and] the pay-
check of the businessman." "So where does my work fit in?" Mau
asks. "What is my relationship to this happy, smiling monster?
Where is the freedom in this regime? Do I follow Timothy Leary
and 'tune in, turn on, drop out?' What actions can I commit that

cannot be absorbed? Can I outperform the system? Can I win?" Is
he kidding?

*

Contemporary design is part of a greater revenge of capitalism
on postmodernism – a recouping of its crossings of arts and disci-
plines, a routinization of its transgressions. Autonomy, even semi-
autonomy, may be an illusion or, better, a fiction; but periodically
it is useful, even necessary, as it was for Loos, Kraus, and company
a hundred years ago. Periodically, too, this fiction can become
repressive, even deadening, as it was thirty years ago when post-
modernism was first advanced as an opening out of a petrified
modernism. But this is no longer our situation. Perhaps it is time
to recapture a sense of the political situatedness of both autonomy
and its transgression, a sense of the historical dialectic of discipli-
narity and its contestation – to attempt again "to provide culture
with running-room."

Often we are told, as we are in *Life Style*, that design can give
"style" to our "character" – that it can point the way to such semi-
autonomy, such running-room – but clearly it is also a primary
agent that folds us back into the near-total system of contemporary
consumerism. Design is all about desire, but strangely this desire
seems almost subject-less today, or at least lack-less; that is, design
seems to advance a new kind of narcissism, one that is all image
and no interiority – an apotheosis of the subject that is also its
potential disappearance. Poor little rich man: he is "precluded from
all future living and striving, developing and desiring" in the neo-
Art Nouveau world of total design and Internet plenitude.

"The transfiguration of the solitary soul appears its goal," Ben-
jamin once remarked of *Style 1900*. "Individualism is its theory . . .
[But] the real meaning of Art Nouveau is not expressed in this

ideology . . . Art Nouveau is summed up by *The Master Builder* [of Henrik Ibsen] – the attempt by the individual to do battle with technology on the basis of his inwardness leads to his downfall."[9] And Musil wrote as if to complete this thought for *Style 2000*:

> A world of qualities without man has arisen, of experiences without the person who experiences them, and it almost looks as though ideally private experience is a thing of the past, and that the friendly burden of personal responsibility is to dissolve into a system of formulas of possible meanings. Probably the dissolution of the anthropocentric point of view, which for such a long time considered man to be at the center of the universe but which has been fading for centuries, has finally arrived at the "I" itself.[10]

MASTER BUILDER

For many people Frank Gehry is not only our master architect but our master artist as well. Projects and prizes, books and exhibitions, flow toward him, and he is often called a genius without a blush of embarrassment. Why all the hoopla? Is this designer of metallic museums and curvy concert halls, luxury houses and flashy corporate headquarters, truly Our Greatest Living Artist?

The notion is telling, for it points to the new centrality of architecture in cultural discourse. This centrality stems from the initial debates about postmodernism in the 1970s, which were focused on architecture; but it is clinched by the contemporary inflation of design and display in all sorts of spheres – art, fashion, business, and so on. Moreover, to make a big splash in the global pond of spectacle culture today, you have to have a big rock to drop, maybe as big as the Guggenheim museum in Bilbao, and here

an architect like Gehry, supported by clients like the Guggenheim and the DG Bank, has an obvious advantage over artists in other media. Such clients are eager for brand equity in the global marketplace – in part the Guggenheim has become brand equity, which it sells in turn to corporations and governments – and these con-

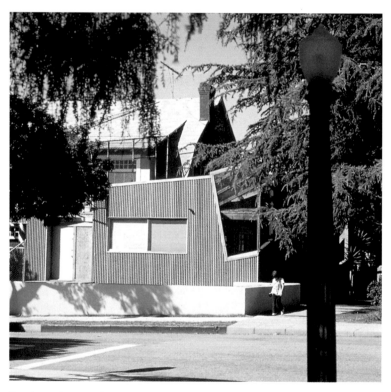

Frank Gehry, *Gehry Residence*, 1977–78, 1991–92, Santa Monica: justly admired but strategically used, it serves as the primal scene of his early architecture.

ditions favor the architect who can deliver a building that will also circulate as a logo in the media. (Bilbao uses its Gehry museum literally as a logo: it is the first sign for the city you see on the road, and it has put Bilbao on the world-tourist map.) But why is Gehry picked out in particular?

His beginnings were humble enough, and he has retained a rumpled sort of everyman persona. Born in Toronto in 1929, Gehry moved to Los Angeles in 1947, where, after stints at Harvard, in Paris, and with various firms, he opened his own office in 1962. Influenced primarily by Richard Neutra, the Austrian émigré who also practiced in the area, Gehry gradually turned a modernist idiom into a funky sort of LA vernacular. He did so mostly in domestic architecture through an innovative use of cheap materials associated with commercial building like exposed plywood, corrugated metal siding, chain-link fencing, and asphalt. As is often the case with architects, his first landmark was the renovation of his own home in Santa Monica (1977–78), which has functioned as a laboratory cum showroom ever since (he redesigned it again in 1991–92). Gehry took a modest bungalow on a corner lot, wrapped it in layers of corrugated metal and chain link, and poked glass structures through its exterior in a way that skewed its given geometries. The result was a simple house extruded into surprising shapes and surfaces, spaces and views. It is justly admired, but also strategically used, for it serves as the primal scene of his practice: "The House that Built Gehry."[1]

Gehry extended the lessons of this house to others in the area, most not built, in which modernist geometries are also disrupted – the plan rotated off axis, the skin pierced by wood bridges, chain-link pavilions, and the like. The unfinished look of this early style seemed right for LA: provisional in a way that was appropriate to its restless transformations, but also gritty in a way that resisted the

glossier side of Tinsel Town. For a time Gehry almost devised a "critical regionalism" of the sort long advocated by Kenneth Frampton, for even as he used new materials, he rejected the formal purities of modern architecture, burst open its abstract boxes, and plunged the rearranged fragments into the everyday ground of Southern California life.[2] But this LA vernacular needed the foil of a reified International Style to make its points, and with the prominence of postmodern architecture in the 1980s, full of classical symbols and Pop images, his style began to lose its edge. Gehry made a subtle compromise with the new postmodern order: though he never fell into the historical pastiche of a Robert Stern or a Charles Moore, he did become more imagistic in his design. One can trace a passage from his early grunge work, through an elliptical Pop style, to his lavish "gestural aesthetic" of the present. For throughout the 1980s and 1990s Gehry went upscale in materials and techniques, clients and projects – from the improvised chain link of Santa Monica to the recherché titanium cladding of Bilbao, from unbuilt houses for local artist-friends to mega-institutions for multinational elites.

This kind of repositioning, in which reception feeds back into production, is neither immediate nor final, but its trajectory is clear enough. Take the cardboard furniture that Gehry designs from cut-out sheets stacked, laminated, and shaped into chairs and divans. When it first appeared in the early 1970s, it was edgy, materially and formally inventive, and potentially low-cost. But as it became more studied as design, the populism of the cardboard began to look *faux* or worse, a kind of homeless chic, attractive only to people far removed from any actual use of the stuff. His Pop tendencies also became more pronounced as the 1980s progressed. Already in his Indiana Avenue Studios (1979–81, in Venice, California), Gehry made imagistic use of both materials and elements: he defined the

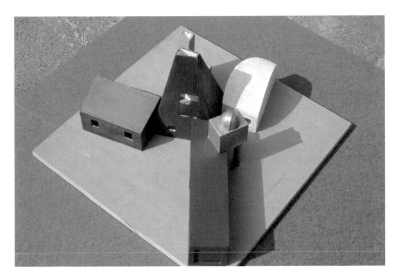

Gehry Partners, *Winton Guest House*, 1983–87, model, Minnesota: with separate rooms cast in bold shapes, the house as a kind of intimate town.

first studio, in blue stucco, by a big bay window; the second, in unpainted plywood, by a huge chimney; and the third, in green asphalt, by giant steps cut into the roof. This typological signaling can be effective in architecture, and Gehry often makes it witty, but it can also be manipulative in its Pop imagery and inflated scale.

In the mid-to-late 1980s Gehry moves back and forth between a material–formal inventiveness and a Pop–imagistic obviousness, and often resorts to a collage of forms and images as a compromise. On the one hand there are projects like the Winton Guest House (1983–87, in Minnesota), in which separate rooms are cast in bold shapes, sheathed in striking materials, and set in a dynamic "pin-wheel plan" that Gehry has often used since. In such domestic projects he composes the house as a kind of intimate town; and

when he turns to commercial projects, such as the Edgemar Development (1984–88, in Santa Monica) he reverses the process, and treats the urban complex as a sort of extended house. This is imaginative, and it can be contextual as well (though like much architecture his rarely engages the ground effectively).[3] On the other hand there are projects that simply go Pop, such as his Chiat Day Building (1985–91, in Venice), where, under the influence of Claes Oldenburg, Gehry designed a monumental pair of binoculars as the entrance to this large advertising agency. This object may suit the client, but it manipulates the rest of us, and reduces architecture to a 3-D billboard. Thereafter the Pop dimension remains strong in his work, even when disguised as a symbolic use of otherwise abstract materials, colors, and forms; and it is no surprise when Gehry begins to design for the Disney Corporation in the late 1980s.

What is at stake here is the difference between a vernacular use of chain link in a house, or of cardboard in a chair, and a Pop use of giant binoculars as an entrance, or of a fighter jet attached to a façade (as in his Aerospace Hall, 1982–84, in LA). Equally at stake is the difference between a material rethinking of form and space, which may or may not be sculptural (here Gehry is influenced by Richard Serra), and a symbolic use of a readymade image or commodity object (here again he is influenced by Oldenburg). The first option can bring elite design in touch with common culture, and renew stale architectural forms with fresh social expressions. The second tends to ingratiate architecture, on the model of the advertisement, to a public projected as a mass consumer. It is this dialectic that Gehry surfed into the early 1990s, and it propelled his jump from LA architect to international designer.

His finessing of architectural labels also allowed this leap: for all that Gehry first extended modern structures and then dallied with postmodern symbols, he is not saddled with the stigmas of either

tag. In effect he trumped the signature styles of both movements in a crafty way that might be understood by reference to *Learning from Las Vegas* (1972), the principal manifesto of postmodern architecture. There, in a famous opposition, Robert Venturi, Denise Scott-Brown, and Steven Izenour distinguished a modern type of design, where "space, structure and program" are subsumed in "an overall symbolic form" – which they called "the duck" – from a postmodern type of design, where "space and structure are directly at the service of program, and ornament is applied independently of them" – which they called "the decorated shed." "The duck is the special building that *is* a symbol," Venturi et al. write; "the decorated shed is the conventional shelter that *applies* symbols."[4] And in an argument that supported the ornamental basis of postmodern architecture, they insisted that, however appropriate the formal duck was to the object world of the machine age, the decorated shed was only fitting for the speedy surfaces of the car-and-television age. As Gehry has privileged neither structure nor ornament, he seemed to transcend this opposition, but it is more accurate to say that he collapsed it, and often combined the formal duck with the decorated shed. One upshot is that his architecture is not really "sculptural" (as is so often claimed), for it breaks down into distinct fronts and backs more often than it reads in the round. Another upshot is that his interiors are difficult to decipher from his exteriors and vice versa, whether one reads them structurally as with the modern duck, or ornamentally as with the postmodern shed. This disconnection between inside and outside can be beguiling, as it is in his Vitra International Headquarters (1988–94, in Switzerland) or his EMR Communications and Technology Center (1991–95, in Germany). But as his "decorated ducks" expanded in scale – as Gehry slouched toward Bilbao – so did the liabilities of this combination, for it risked the most problematic aspects of both modern and postmod-

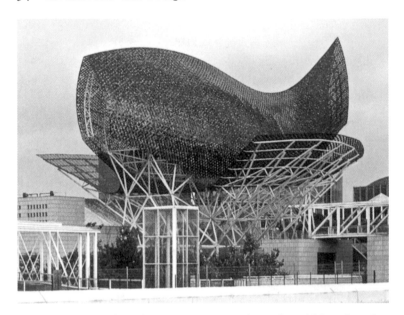

Gehry Partners, *Fish Sculpture*, 1989–92, Barcelona: the gold leviathan that marks his first use of computer-aided design.

ern architectures: the willful monumentality of the first and the *faux* populism of the second.

Gehry combined formal duck and decorated shed almost literally in his huge Fish Sculpture designed for the Olympic Village in Barcelona in 1992, a work at once eccentric and central to his career (he has adopted the fish as his "private totem"). If the Santa Monica house was the primal scene of his early career, this gold-ribbed leviathan is the primal scene of his later career, for it marks his first use of a technology that has guided his practice (and many others) ever since – computer-aided design and manufacture (a.k.a. CAD and CAM), in particular a program called CATIA (computer-aided

three-dimensional interactive application). Developed first in auto-
mobile and aerospace industries, such programs are also used in
film animation, and Fish Sculpture does resemble a futuristic fossil
version of the dinosaurs of *Jurassic Park* (maybe it can serve as a
prototype when Disney animates *Moby Dick*). A trellis hung over
arched ribs, the Fish is equal parts duck and shed; a combination of
Serra and Oldenburg, it is both all structure and all surface, with no
functional interior. And yet his CATIA-designed buildings also
privilege shape and skin, the overall exterior configuration, above
everything else. In large part this is because CATIA permits the easy
modeling of non-repetitive surfaces and supports, of different
exterior panels and interior armatures, and this permission has
induced Gehry to play with wacky topologies that overwhelm
straight geometries – hence all the non-Euclidean curves, swirls, and
blobs that became his signature gestures in the 1990s.

These effects are most evident in the Guggenheim Bilbao

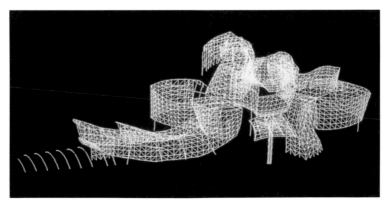

Gehry Partners, *Guggenheim Museum Bilbao*, 1991–97: an imagistic cross
between a wrecked ocean-liner and a crashed space-ship.

(1991–97), "the first major project in which the full potential of the [CATIA] program was realized." (CAD and CAM are said to be cost-effective, but they are not necessarily so, and their use is as much rhetorical as actual. For example, the thin titanium panels in Bilbao were partly cut on site and manually bent into place.) Imagistically a cross between an oceanliner run aground and a space-ship landed in the Basque Country (call it the *Titanium*), this Bilbao museum is deemed the masterpiece of his "sculptural" style, and it has served as the model of his subsequent mega-projects, such as the Walt Disney Concert Hall in LA (under construction), the Experience Music Project in Seattle (1995–2000), and the proposed Guggenheim near Wall Street (a project that may be on hold with the destruction of the World Trade Center).

<p style="text-align:center">*</p>

Here we might return to the claim that Gehry is our great artist, or at least our great sculptor. But first we need some version of modern sculpture to go by, and a good one (certainly a laconic one) comes from Carl Andre, a Minimalist sculptor of the kind said to have influenced Gehry. "I want to give you the three phases of art as I know it," Andre remarked in a 1970 radio interview, with the Statue of Liberty as his test-case. "There was a time when people were interested in the bronze sheath of the Statue of Liberty, modeled in [Bartholdi's] studio. And then there came a time when artists ... were interested in Eiffel's iron interior structure, supporting the statue. Now artists are interested in Bedloe's island [the site of the statue]."[5] Andre sketches here a particular passage in modern sculpture – from the academic modeling of the human figure supported by a hidden armature (most statues are like the Statue of Liberty in this regard), to the modernist exposure of the "interior structure" of the object (think of the open framework of Construc-

tivist sculpture of the 1920s), to the contemporary interest in a given place – the expanded field of sculpture that extends from earthworks in the 1960s and 1970s to site-specific projects of various sorts today.

How does Gehry the architect–sculptor fit into this history? In effect he performs a time-loop. Like many other new museums, his colossal spaces are designed to accommodate the expanded field of postwar art – of Andre, Serra, Oldenburg, and assorted descendants. But actually these museums trump this art: they use its great scale, which was first posed to challenge the modern museum, as a pretext to inflate the contemporary museum into a gigantic spectacle-space that can swallow any art, let alone any viewer, whole. In short, museums like Bilbao use the breaking-out of postwar art as a license to corral it again, and to overwhelm the viewer as they do so. At the same time, considered as sculpture, the recent Gehry buildings appear regressive, for they reverse the history of the medium sketched above. For all the apparent futurism of the CATIA designs, these structures are akin to the Statue of Liberty, with a separate skin hung over a hidden armature, and with exterior surfaces that rarely match up with interior spaces. (This comparison might not be fair to the Statue of Liberty, for it involves an innovative interplay between structure and skin, whereas Gehry allows his skin to dominate his structure.) Again, Gehry is frequently associated with Serra, but Serra exposes the construction of his sculptures for all to see, and Gehry is often tectonically obscure. Some of his projects resemble the baubles set on corporate plazas in the 1960s and 1970s blown up to architectural scale, and some look as though they could be broken into with a can-opener.

With the putative passing of the industrial age, modern architecture was declared outmoded, and now the Pop aesthetic of postmodern architecture looks dated as well. The search for the architecture of the computer age is on; but, ironically, it has led

Gehry and followers to academic sculpture as a model, at least in part. (Imagine a new ending to *Planet of the Apes* where, instead of the Statue of Liberty uncovered as a ruin in the sand, the Guggenheim Bilbao pokes through, or the Fish Sculpture in Barcelona.) The disconnection between skin and structure represented by this academic model is most radical in the Experience Music Project, commissioned by Microsoft billionaire Paul Allen out of his love for Jimi Hendrix (a fellow Seattleite): its six exterior blobs clad in different-color metals have little apparent relation to its many interior display-stations dedicated to popular music. Just as Gehry moved to make Bilbao legible through an allusion to a splintered ship, here he compensates with an allusion to a smashed guitar (a broken "fret" lies over two of the blobs). But neither image works, even as a Pop gesture, for you have to be well above both to read them as images at all, or you have to see them in media reproduction – which, again, is a primary "site" of such architecture.

Mine is not a plea for a return to a modernist transparency of structure (that was mostly a myth anyway, even with purist architects like Mies van der Rohe). I am simply opposed to a computer-driven version of a Potemkin architecture of conjured surfaces. For the disconnection between skin and structure in Gehry can have two problematic effects. First, it can lead to spaces that are not surprising (as in the early houses) so much as mystifying (as in Bilbao or Seattle) – a strained disorientation that is frequently mistaken for an Architectural Sublime. (Sometimes it is as if Gehry and followers have taken the famous critique of delirious space in postmodern architecture, first presented by Fredric Jameson in the early 1980s, as a guideline for practice – as if they designed in keeping with "the cultural logic of late capitalism.")[6] Second, this disconnection can abet a further disconnection between building

and site. The Bilbao museum is said to "adapt to its setting with billowing forms that face the [Nervion] river and evoke marine imagery." Likewise the metallic curves and swirls of the proposed Guggenheim near Wall Street are said to mediate, like so many waves and clouds, between the East River in front (the museum is to span three piers) and the downtown skyscrapers in back (it includes its own tower). But the claim that Gehry is sensitive to context does not hold up: the Wall Street Guggenheim is even more anti-contextual than the Bilbao, which here has come home to roost, swollen to twice the size, and propped up on super-pylons like a giant metal Dodo. (Its fate might now be worse than the Dodo's – extinct before birth.)

An obvious point of comparison for the Gehry Guggenheims is the Frank Lloyd Wright Guggenheim (1959). It too is often seen as a sculptural object, but the Wright has a formal logic, the whitish

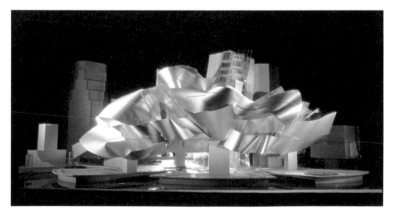

Gehry Partners, *Guggenheim Museum New York*, 1998- , model: the Bilbao museum come home to roost, swollen to twice the size and propped up on super-pylons.

spiral, as well as a programmatic conceit, the museum as continuous ramp, that the Gehrys do not possess. Moreover, the Wright uses its difference from its context smartly, as it breaks with the line of Fifth Avenue and bows into the greenery of Central Park. In a word, its form is expressive because it appears motivated in different ways. Can the same be said of the "gestural aesthetic" of Gehry? The gestures of his early houses were often idiosyncratic, but they were also grounded in two ways – in an LA vernacular of common materials and against an International Style of purist forms. As these gestures began to lose the specificity of the former and the foil of the latter, they became not only more extravagant (almost neo-Expressionist or neo-Surrealist) but also more detached as signs of "artistic expression" that could be dropped, indifferently, almost anywhere – in LA, Bilbao, Seattle, Berlin, New York ... Why this curve, swirl, or blob here, and not that one? Formal articulation requires a resistant material, structure or context; without such constraint architecture quickly becomes arbitrary or self-indulgent. (Here again part of the problem might be the technical facility of CATIA, which is said to translate "the gestural quality from model to built work" all but directly.) The great irony is that Gehry fans tend to confuse this arbitrariness with freedom, that self-indulgence with expression. *The New York Times* greeted his recent retrospective with the banner "Gehry's Vision of Renovating Democracy."

So what is this vision of freedom and expression? Is it perverse of me to find it perverse, even oppressive? In the sense of Gehry as Our Great Living Artist, it is oppressive because, as Freud argued long ago, the artist is the only social figure allowed to be freely expressive in the first place, the only one exempted from many of the instinctual renunciations that the rest of us undergo as a matter of course.[7] Hence his free expression implies our unfree inhibition, which is also to say that his freedom is mostly a franchise in which

he represents freedom more than he enacts it. Today this exceptional
license is extended to Gehry as much as to any artist, and certainly
with greater consequences.

In another sense this vision of expression and freedom is
oppressive because Gehry does indeed design out of "the cultural
logic" of advanced capitalism, in terms of its language of risk-taking
and spectacle-effects. Long ago in "The Social Bases of Art" (1936)
Meyer Schapiro argued that the Impressionist painter was the first
artist to address the new modern world of speed and surface. "For
this individual," Schapiro wrote, "the world is a spectacle, a source
of novel pleasant sensations, or a field in which he may realize his
'individuality,' through art, through sexual intrigue, and through
the most varied, but non-productive, mobility."[8] So it is still today
– for our privileged artists, architects, and patrons – only more so.
Yet "such an art cannot really be called free," Schapiro cautioned,
"because it is so exclusive and private"; to be deemed free at all, its
"individuality must lose its exclusiveness and its ruthless and per-
verse character."[9]

In a similar way Gehry evokes an individuality that seems more
exclusive than democratic. Rather than "forums of civic engage-
ment," his cultural centers appear as sites of spectacular spectator-
ship, of touristic awe. In *The Society of the Spectacle* (1967) Guy
Debord defined spectacle as "capital accumulated to the point where
it becomes an image."[10] With Gehry and other architects the reverse
is now true as well: spectacle is "an image accumulated to the point
where it becomes capital." Such is the logic of many cultural centers
today, as they are designed, alongside theme parks and sports
complexes, to assist in the corporate "revival" of the city – that is,
of its being made safe for shopping, spectating, and spacing out
(more on which in Chapter 4). "The singular economic and cultural
impact felt in the wake of its opening in October 1997," we are told

of "the Bilbao effect," "has spawned a fierce demand for similar feats by contemporary architects worldwide." Alas, so it has, and (terrorist targets notwithstanding) it is likely to come to your hometown soon.

ARCHITECTURE AND EMPIRE

In *Delirious New York* (1978), his "retrospective manifesto" for Manhattan, Rem Koolhaas published an old tinted postcard of the city skyline of the early 1930s. It presents the Empire State, Chrysler, and other landmark buildings of the time with a visionary twist – a dirigible set to dock at the spire of the Empire State. It is an image of the twentieth-century city as a spectacle of new tourism, to be sure, but also as a utopia of new spaces – of people free to circulate from the street, through the tower, to the sky, and back down again. (The image is not strictly capitalist: the utopian conjunction of skyscraper and airship appears in revolutionary Russian designs of the 1920s as well.) The attack on the World Trade Center – of the two jets flown into the two towers – was a dystopian perversion of this modernist dream of free movement through cosmopolitan space. Much damage was done to this great

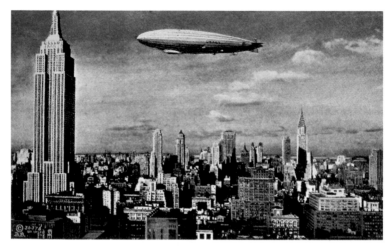

The Manhattan skyline in a postcard of the early 1930s.

vision of the skyscraper city – and to New York as the capital of this dream.

In *Delirious New York* Koolhaas celebrates Manhattan for its "culture of congestion." The skyscraper is the crux of this culture, and he sees it as a mating of two emblematic forms that appear in various guises from the first New York Fair of 1853 to the World Fair of 1939 – "the needle" and "the globe." The needle in the skyscraper is what demands "attention," the globe is what promises "receptivity," and "the history of Manhattanism is a dialectic between these two forms." After 11 September the discursive frame of this Manhattanism has shifted somewhat. New fears cling to the skyscraper as a terrorist target, and the values of "attention" and "receptivity" are rendered suspicious. The same holds for the values of congestion and "delirious space"; they are overshadowed by calls for surveillance and "defensible space." In short, the "urbanistic

ego" and cultural diversity that Koolhaas celebrates in *Delirious New York* are under enormous pressure. They need advocates like never before, for, to paraphrase the Surrealists, New York Beauty will be delirious or will not be.

Luckily, we have the example of Koolhaas, who may be the most gifted architect-polemicist since Le Corbusier; certainly like Corb he possesses great panache in design and writing alike. Born in Holland in 1944, Koolhaas first worked as a journalist and a screenwriter in Amsterdam, and his approach to architecture and urbanism has remained investigative and cinematic. After study at the Architectural Association in London in the early 1970s, he founded his Office for Metropolitan Architecture (OMA) with three associates in 1975, and centered it in Rotterdam in 1978. For the first ten years of its existence, texts greatly outnumbered buildings; since then they have run neck and neck, and huge books like *S, M, L, XL* (1995) – a mega-volume that transformed design publishing – are needed to encompass both. Based on research directed at Harvard since 1995, his new publications concerning mutations of the contemporary city are also vast, and more of these collective projects are on the way.

It was in Manhattan, while a fellow at the Institute of Architecture and Urban Studies in the middle 1970s, that Koolhaas had his epiphany of the Metropolis. Billed as retroactive, *Delirious New York* was also anticipatory in the usual manner of the manifesto: "it is the arduous task of the final part of this century," Koolhaas concludes, "to deal with the extravagant and megalomaniac claims, ambitions and possibilities of the Metropolis *openly*." OMA was to lead this "second coming of Manhattanism": if the essence of Manhattanism was "to live inside *fantasy*," then OMA would be a "machine to fabricate fantasy," and its first proposals were more surreal narratives than practical programs (e.g., a model for mass

housing in the form of a luxury hotel named The Sphinx).[1] Koolhaas has never let go of this Surrealist dimension of the oneiric and the outlandish in his designs.

Much of OMA is embryonic in *Delirious New York*. Koolhaas focuses on emblematic structures of the city, such as Central Park, the "colossal leap of faith" laid out long before the buildings that frame it, and Coney Island, the testing ground of "the Technology of the Fantastic" for the rest of New York. But his heart belongs to the Manhattan Grid, the twelve north–south avenues and 155 east–west streets drawn on open land in 1807. The Grid was all about real estate speculation (John Jacob Astor made his fortune not by trading furs, as American folklore has it, but by buying up blocks as the city pushed north); nevertheless, Koolhaas calls it, with Corbusierian hyperbole, "the most courageous act of prediction in Western civilization." For the Grid allowed different forms and functions to be juxtaposed at the level of the block, the "maximum unit of urbanistic Ego," while the Skyscraper (the Grid writ small) did the same at the level of the floor. The result is "a mosaic of episodes . . . that contest each other," the oxymoronic city that we love and hate today – "ordered and fluid, a metropolis of rigid chaos." This double schism between regular Grid and irregular Skyscrapers and single façade and multiple floors is fundamental to Manhattanism, for the dissociation of exteriors and interiors "not only resolves forever the conflict between form and function, but creates a city where permanent monoliths celebrate metropolitan instability."[2] With this "lobotomy" architecture can pretend to be intact while the city continues to change all around it. Koolhaas echoes Baudelaire on modernity here ("I mean the ephemeral, the fugitive, the contingent, the half of art whose other half is the eternal and the immutable"); this is the glory of Manhattan for Koolhaas too, and it runs deep in his architectural–urban DNA.[3]

Despite its cult status today, *Delirious New York* was untimely. "How to write a manifesto," the book begins, "in an age disgusted with them," indeed with all things modernist and urbanist? For 1978 was the early heyday of postmodern architecture, urban schemes were in great disrepute, New York was bankrupt, and other American cities were compromised by white (tax) flight as well. Yet "untimely" can also mean "strategic," and *Delirious New York* emerged in a context stretched between opposite models of the city that left Koolhaas lots of room to manoeuvre. On one side were the Krier brothers (Leon and Rob), who insisted on a return to the historic *quartier* as the basis of urban planning in Europe; on the other side were Robert Venturi, Denise Scott-Brown, and Steven Izenour, who advocated an embrace of the commercial strip in the US ("billboards are almost all right," they proclaimed in 1972 in *Learning from Las Vegas*, a manifesto to which *Delirious New York* tacitly responds).[4] Koolhaas could reject the reactionary historicism of the former and the commercial populism of the latter, and reject as well the pop-historicist compromise between the two that became the common recipe of postmodern design. That part was easy enough; the gutsier move was not to repudiate modernism, as so many did at the time, but to relocate its exemplary form in a neglected episode. Long ago Le Corbusier, Walter Gropius, and other young Europeans had adopted overlooked structures like American grain elevators as emblems of a functionalist modernism to come. In *Delirious New York* Koolhaas claimed another sort of American primitive as a prototype for a renewed modernism – the pragmatic architects of Skyscraper Manhattan such as Raymond Hood and Wallace Harrison, the chief designers of the Rockefeller Center (among other projects).

This was strategic because European modernism à la Corb and Gropius was despised at the time, especially for its utopian aspect,

while American modernism à la Hood and Harrison was not so stigmatized: "at once ambitious and popular," it was also built. Koolhaas took this pragmatic example home to Europe in the late 1970s, and it allowed him to split the difference between the Krier and Venturi/Scott-Brown positions, as he geared OMA toward "polemical demonstrations that aspects of modernism, both American and European, can be made to co-exist with the historical core, and that only a new urbanism that abandons pretensions of harmony and overall coherence can turn the tensions and contradictions that tear the historical city apart into a new quality." His timing was right, for Europe was about to undergo a "second modernization." In the US political power had ceded control to economic power, as Reagan moved Wall Street to the White House and social life seemed administered by multinational corporations. These corporations required symbolic representation, and postmodern design suited this corporate kind of logo-architecture well. But in Europe governments still had a stake in *grands projets* that looked to the future, especially with a "New Europe" to construct after 1989. "We identified ourselves with these programmatic adventures," Koolhaas recalls in *S, M, L, XL*; "it seemed that the impossible constellation of need, means, and naiveté that had triggered New York's 'miracles' had returned."[5] Although he foresaw that this rediscovery of architecture might devolve into "a Faustian gambit," the allure of the Big Footprint, "posed seriously for the first time in Europe," was impossible to resist.

OMA participated in several state competitions and won a few. Like Europe as a whole, 1989 was its *annus mirabilis*, its "first dose of bigness." For a sea terminal at Zeebrugge, Belgium, OMA proposed an innovative structure that crossed a sphere with a cone (Koolhaas likened it to an inverted Tower of Babel), with ferry traffic below, a bus station in the middle, parking above, and a

OMA, *Bibliothèque de France,* 1989, model: a luminous block out of which spaces might be carved as needed.

panoramic hall on top. His project for the Very Big Library in Paris (well named at 250,000 square meters) was a luminous block out of which spaces could be carved as needed, and his Center for Art and Media Technology in Karlsruhe stacked studios and laboratories, a theater, a library, a lecture hall, and two museums behind a façade on which cinematic images could be screened. For different reasons all three projects fell through, but in the process OMA received the biggest prize of all, the master plan for "Euralille" (1990–94), a new center for the New Europe in Lille, a city returned to prominence by Chunnel and train connections. OMA sited a TGV station, two centers for commerce and trade, and an urban park, all produced

OMA, *International Business Center with Congrexpo in foreground*, 1990–94, model, Lille: "Bigness" at work in the new European hub.

by other architects, but saved "Congrexpo" for its own design – a contemporary Grand Palais in the shape of a deformed scallop, with a large concert hall, three auditoria (the "congress" part), and an exhibition space (the "expo" part).

As OMA developed this practice of Bigness, Koolhaas developed his theory. "In spite of its dumb name, Bigness is a theoretical domain at this *fin de siècle*," he wrote in 1994. "In a landscape of disarray, disassembly, dissociation, disclamation, the attraction of Bigness is its potential to reconstruct the Whole, resurrect the Real, reinvent the collective, reclaim maximum possibility." With this grand rhetoric "coexistence with the historical core" was no longer a priority: Koolhaas pitched Bigness as "the one architecture that can survive, even exploit, the now-global condition of the tabula rasa."[6] In effect it was Manhattanism without Manhattan: like the Skyscraper-Block returned in a single building, these new mega-structures would permit a great variety of programs, and they would not be constrained by any Grid. "Bigness is no longer part of any urban tissue"; rather, like Euralille, it could serve as its own mini-city. "This architecture relates to the forces of the *Groszstadt* like a surfer to the waves," Koolhaas remarked of Skyscraper Manhattan in *Delirious New York*.[7] By the early 1990s the same could be said of his own designs, and it might not sound like praise. Indeed, in his new books Manhattanism and Bigness have come back to haunt him in other guises.

In 1995, a year after the Lille plan was finished, *S, M, L, XL* was published, a lavish compendium of "essays, manifestoes, diaries, fairy tales, travelogues, a cycle of meditations on the contemporary city, with work produced by OMA over the past twenty years," all arranged according to scale.[8] It is a long way from the days when OMA practiced paper architecture: *S, M, L, XL* opens with daunting graphs of income and expenditure, airline miles and hotel nights.

Koolhaas had come to write "retroactive manifestoes" for his own work, and texts and buildings often reflect on one another in a way that clarifies a method common to both. In *Delirious New York* he evoked the "paranoid–critical method" of Salvador Dali – a Surrealist way of reading in which a single motif is seen in multiple ways in a "delirium of interpretation": "The PCM promises that, through conceptual recycling, the worn, consumed contents of the world can be recharged or enriched like uranium."[9] In effect Koolhaas adapted this typological reprogramming as the formula for his own work too: in a "systematic overestimation of what exists," he often extrapolates one architectural element as the basis of his designs, or one urban structure like the Skyscraper or the Grid into a social agent or a historical subject in his writings. This extrapolation is performed not in order to affirm the commercial given, as Venturi et al. do in *Learning from Las Vegas*, nor to redeem the historical past, as Aldo Rossi advocated in his influential *Architecture of the City* (1966); yet, ideally, it has some of the communicative potential of the former and some of the mnemonic resonance of the latter. In any case Koolhaas has pursued this typological "overestimation" from a 1971 study of the Berlin Wall, through a 1987 appreciation of the massive atriums of the hotel designer–developer John Portman, right on to the new books on contemporary structures of shopping in the West and on urban development in the Pearl River Delta in China.

Over this time, however, a shift in context provoked a shift in thinking. By the late 1980s Koolhaas spoke less of congestion, as in *Delirious New York*, and more of "voids" and "nothingness." His Paris library was conceived expressly as a "void," and the Lille plan looked back to urban models (such as the Broadacre City concept of Frank Lloyd Wright) that also "imagined nothingness." Perhaps Koolhaas sensed that the new economy of media and communi-

cations might not abet a further dissolution of the city, its final death, as architectural futurists like Paul Virilio had forecast, but rather its greater congestion, its metastatic life, as political economists like Saskia Sassen would soon insist. On this score his new publications are peppered with statistical alarms: "In 1950, only New York and London had over eight million inhabitants. Today there

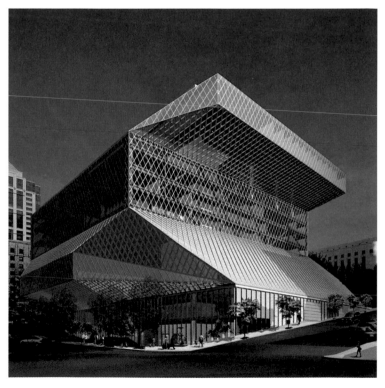

OMA, *Seattle Public Library*, 1999–, model: will communications media reclaim a density for the city or dissolve it further?

are twenty-two megalopolises. Of the 33 megalopolises predicted in 2015, twenty-seven will be located in the least developed countries, including nineteen in Asia"[10] As in a fairy tale, Koolhaas was granted only a parody of his old wish for density and bigness, and in the context of globalization both architectural and urban principles had to be rethought. "Do any of us have the terms of reference to really judge their success or failure?" he asked in 1991.[11]

<div align="center">*</div>

In 1995 Koolhaas began to teach at the Harvard Graduate School of Design, where he initiated "the Project on the City," a research program conducted by thesis students "to document and understand the mutations of urban culture . . . that can no longer be described within the traditional categories of architecture, landscape, and urban planning."[12] Each project culminated in another megabook of lavish images, statistics, and texts. *Harvard Design School Guide to Shopping* was the first to appear, followed closely by *Great Leap Forward*, which concerns the intensive urbanization of the Pearl River Delta from Hong Kong to Macao. Next comes a casestudy of West African urbanization centered on Lagos, Nigeria, and an account of the "operating system" of the Roman city (basilica, forum, temple, etc.) as a prototype for subsequent Empire-building – including, in the idiom of Michael Hardt and Antonio Negri, our own Empire of supranational sovereignty and global capitalism.[13]

Harvard Design School Guide to Shopping is a compendium of forty-five essays by fifteen participants with the usual killer images and stats (e.g., yearly sales at WalMart exceed the GNPs of three-quarters of the countries in the world; total retail area in the world is equal to thirty-three Manhattans, of which over a third exists in the US; and so on). At once technological and economic, social and cultural, the analysis tracks postindustrial consumption as it trans-

forms the city almost as much as industrial production did. (Many cities are now hybrids of these two orders, with the fixed structures of the latter often retro-fitted to the fluid demands of the former.) *Shopping* is especially good on the postwar "malling" of suburban and urban space, from the first godfather of the mall, Victor Gruen, to the current one, Jon Jerde. The key inventions here are the air-conditioner, which opened up vast interiors to buying and selling, and the escalator, which allowed shoppers to traverse these new expanses with distracted ease. Together they have made for a new smoothness of space that "denies the relevance of both compartments and floors," and the mall could not have emerged in the mid-1950s without them.[14] An earlier nexus of the elevator and the automobile had abetted the arrangement of offices and stores concentrated in downtown buildings with homes and schools dispersed in suburban peripheries; the nexus of the escalator and the air-conditioner helped to fill in the suburbs with shopping, as it were, and to render them semi-autonomous. In recent decades, however, the suburban mall has returned to the city, home of its antecedents the arcade and the department store. As a result, John McMorrough writes here, "The city has twice been humiliated by the suburbs: once upon the loss of its constituency to the suburbs and again upon that constituency's return. These prodigal citizens brought back with them their mutated suburban values of predictability and control."[15]

Shopping conceives shopping as a parasite so successful that it has become the host. The book begins:

Shopping is arguably the last remaining form of public activity. Through a battery of increasingly predatory forms, shopping has been able to colonize – even replace – almost every aspect of urban life. Historical town centers, suburbs, streets, and now

train stations, museums, hospitals, schools, the internet, and even the military, are increasingly shaped by the mechanisms and spaces of shopping. Churches are mimicking shopping malls to attract followers. Airports have become wildly profitable by converting travelers into consumers. Museums are turning to shopping to survive. The traditional European city once tried to resist shopping, but is now a vehicle for American-style consumerism. 'High' architects disdain the world of retailing yet use shopping configurations to design museums and universities. Ailing cities are revitalized by being planned more like malls . . .

In this analysis, as megastores govern more and more movement through cities, architecture and urbanism are more and more exposed as the mere coordination of flow. Yet the very victory of the megastore may spell its eventual defeat, for like its products it is "always almost obsolete," and by 2010 more than half of all retail is projected to occur through mail-order and on-line: if the shopper won't come to the store, the store must go to the shopper.[16] Some of the best essays in *Shopping* treat the remapping of city and suburb alike as statistical "control space" where citizen-consumers are tracked, with "bit structures" and other electronic traces, according to "economic performance." Already on the horizon is "segment-one selling" or niche-marketing one person at a time (even now some telemarketers know your nickname).

Schooled in apocalyptic criticism, the young authors of *Shopping* present too many of these developments as new; nevertheless, shopping has reached a new level of saturation. For instance, what Chuihua Judy Chung calls "Disney Space" – the copyrighting of familiar things and public places as commercial icons and private zones – is now pervasive: "Starbucks" refers to high-octane coffee, not the good officer of the *Pequod*. And *Shopping* underscores several ruses of urban history that can no longer be ignored. In

S, M, L, XL Koolhaas had argued that "the historic façades of [European] cities often mask the pervasive reality of the un-city"; *Shopping* extends this insight to the US, and traces a perverse line from urbanist Jane Jacobs to "Disney Space," whereby the very preservation of the city core sometimes produced a nonurban void that was later subject to malling.[17] A dialectical twist of this sort has also jumped up and bitten Koolhaas, for *Shopping* can be read as a tacit repudiation of Bigness. He contributes but one essay to the book, a great diatribe titled "Junkspace," which reviles the vapid non-architected spaces that have filled so many mega-structures today – schemes that not long ago he appeared to advocate.

By the same token *Great Leap Forward* is not only a play on Mao and his old economic initiative; it is also a rethinking of Manhattanism and its Culture of Congestion:

Asia has been in the grip of a relentless process of building, on a scale that has probably never existed before. A maelstrom of modernization is destroying, everywhere, existing Asian conditions and creating, everywhere, completely new urban substance. The absence, on the one hand, of plausible, universal doctrines, and the presence, on the other, of an unprecedented intensity of new production, create a unique wrenching condition: the urban condition seems to be least understood at the moment of its very apotheosis . . .

This Project on the City, focused on the Pearl River Delta, seeks such understanding. An area only a little larger than the Dutch Randstad, the PRD is projected to reach a population of thirty-four million by 2020. Along with Hong Kong and Macao, it includes the special economic zones of Shenzhen and Zhuhai, which Koolhaas calls "vitrines for the policy of openness," as well as Guangzhou (Canton) and Dongguan. According to *Great Leap Forward*, these

cities are defined almost diacritically in a field of attraction and repulsion. The most important of the seventy-one terms copyrighted in the book is "Coed©":

> The City Of Exacerbated Difference is based on the greatest possible difference between its parts – complementary or competitive. In a climate of permanent strategic panic, what counts in the city of exacerbated difference is not the methodical creation of the ideal, but the opportunistic exploitation of flukes, accidents, and imperfections.

Thus Shenzhen, which borders Hong Kong, is a cheaper version of its famous neighbor, and it has experienced the most intensive urbanization as a result – some 900 new towers in a seven-year span. Across the delta from Hong Kong, Zhuhai is defined as its opposite, a would-be garden city set on a tabula rasa that *Great Leap Forward* terms "Scape©," without the distinctive features of either city or landscape. This urbanization has occurred under "unprecedented pressures of time, speed, and quantity" (in China there is one-tenth the number of architects in the US, with five times the project volume), and it points to a general crisis in architecture, landscape design, and urbanism alike. "The field is abandoned to 'events' that are considered indescribable," Koolhaas writes, "or the creation of a synthetic idyll in memory of the city. There is nothing between Chaos and Celebration."[18]

The PRD is an extraordinary mix of command and market economies, which *The New York Times* is pleased to call "Market Leninism." As is his wont, Koolhaas keys on a typological icon that seems to express this strange combination of fixity and flux, and it comes in the unexpected form of a seventy-five-mile highway, privately owned by a Hong Kong developer named Gordon Wu, that connects some of the urban centers. Suspicious of the Chinese

government, Wu had the entire turnpike built as a viaduct above ground; it only touches down at intersections where he has ordained future urbanization to occur. On the model of the Communist utopias offered up in Socialist Realism, Koolhaas terms this sort of project "Market Realism©": "a brilliant formula for desire simultaneously deferred and consummated" based on "the present interval between market promise and market delivery." Many high-rises in Shenzhen have sprung out of this same gap: this is real estate designed less for occupation (the tenancy is extremely low) than for investment (there is a stock market dedicated to these buildings).

However unique, the PRD is also telling of modernization today, just as New York was in the 1920s and 1930s and the New Europe in the 1980s and '90s. Manhattan is emblematic of an object-world of monumental architectures born of a Fordist economy that is relatively fixed (great bridges, factories and warehouses, skyscrapers). As the economy becomes more post-Fordist, capital flows evermore rapidly in search of cheap labor, manufacturing innovation, deregulated financing, and new markets, and the life expectancy of most buildings falls dramatically. Paradoxically, this condition appears heightened in the PRD, and it is not pretty. As *Great Leap Forward* tells it, many structures are refashioned continuously, and some are taken down almost before they are put up. In such fluidity the Baudelairean conjunction of the eternal and the ephemeral no longer applies; or, as Koolhaas wrote of the architect in 1994: "His task is truly impossible: to express increasing turbulence in a stable medium."[19] Today any architect empowered enough to surf "the forces of the *Groszstadt*" seems destined to crash on the beach. One hopes that future Projects on the City will consider what alternatives exist.

As it is, the Project has its own incipient "Coed" logic: it

sketches a diacritical field of global cities that display different aspects of contemporary modernization: the advanced-capitalist malling of affluent cities in *Shopping*, the command-market hybrid of the PRD in *Greap Leap Foward*, the informal economies that shape Lagos in the book to come. Where are we to locate Koolhaas in this Empire? Walter Benjamin once feared that if he emigrated to the US he would be carted around with a sign that read "The Last European"; for all his work on other continents Koolhaas might exemplify this European modernist today. In *Delirious New York* he counterposed Le Corbusier and Dali as enemy twins, and his unspoken ambition was to reconcile the two – Corb the master architect-urbanist, Dali the "paranoid–critical" artist-analyst. "To encompass both Breton and Le Corbusier," Benjamin once remarked, "that would mean drawing the spirit of contemporary France like a bow, with which knowledge shoots the moment in the heart."[20] This insight extends beyond interwar Paris, for to encompass figures like Corb and Dali (or Breton) is to mediate not only opposed avant-gardes, rationalist and irrationalist, but also different projects within modernity – projects, associated with Marx and Freud, of social transformation and subjective liberation. Such mediation was the mission of several avant-gardes after the war (Situationism prominent among them): to ride the dialectic of modernization in a way that might keep these projects alive for the future.

Koolhaas surfs this dialectic better than anyone in the present, but his very skill has made for some ambiguous moves. It has led him to critique the contemporary apotheosis of shopping, yet also to serve as house architect of Prada (which has published his designs for three new "epicenters" in New York, Los Angeles, and San Francisco in another mega-book). It has led him to open an innovative complement to OMA called AMO dedicated to intervene

critically in the expanded field of design, yet also to sign on as consultant to Condé Nast in its bid to refashion its magazine empire.[21] It has led him to oppose the spectacle-architecture of the sort promoted by institutions like the Guggenheim Museum, yet also to design a Guggenheim gallery in Las Vegas (albeit a non-spectacular one). This is no simple story of cooption: architecture must attend to the *Groszstadt*, if not surf it, and it is difficult to imagine a politics today that does not negotiate the market some-how. If Situationist *détournement* is improbable in present circum-stances, at least Koolhaas and company remain adept at critical insights and provocative schemes, though his deconstructive method of "systematic overestimation" and rhetorical reversal can lapse into glib conflation. (If the museum tends toward the store today, Koolhaas asks in the Prada book, why not a store that serves, at least in part, as a museum? And in his New York Prada he has designed a display room by day that can be used as a performance theater at night, but this is likely to be more "Disney Space" than "alternative space.") Finally, to what ends are these insights and schemes put? Is OMA/AMO an avant-garde without a project beyond innovative design?[22]

The Project on the City sometimes calls to mind an impossible crossing of Situationist *flâneur* and Baron Haussmann. Living with such contradictions aligns Koolhaas once more with Baudelaire, especially his dandy. Baudelaire captured the political ambivalence of this figure in a passage that Koolhaas has also cited: "I understand how one can desert a cause in order to experience the sensation of serving another. It would perhaps be pleasant to be alternately victim and executioner."[23] Behind this bravado there is desperation: certainly great poetry can come of this ambivalence, and not a little critique; but that may be all. On this score Koolhaas should have the last word here, "a reply to my critics":

I have never thought of our activity as "affecting change." I'm involved with how "everything" changes in ways that are often radically at odds with the core values of architecture. In spite of its apparent success, I see "Architecture" as an endangered brand, and I'm trying to reposition it. To me, it is ironic that the (I would almost use the word "innocent") core of our activity – to reinvent a plausible relationship between the formal and the social – is so invisible behind the assumption of my cynicism, my alleged lack of criticality, our apparently never-ending surrender . . .[24]

PART II
ART AND ARCHIVE

ARCHIVES OF MODERN ART

The archives of my title are not the dusty rooms filled with dry documents of academic lore. I mean the term as Michel Foucault used it, to stand for "the system that governs the appearance of statements," that structures the particular expressions of a particular period.[1] In this sense an archive is neither affirmative nor critical per se; it simply supplies the terms of discourse. But this "simply" is no small thing, for if an archive structures the terms of discourse, it also limits what can and cannot be articulated at a given time and place. Here I want to sketch a few significant shifts in the dominant archival relations that obtained among modern art practice, art museum, and art history in the West circa 1850–1950. A little more specifically, I want to consider the "memory-structure" that these three agencies co-produced over this period, and to describe a "dialectics of seeing" within this memory-structure (I trust these

terms will become clearer as I go along).² I will focus on three particular moments – perhaps more heuristic than historical – and I will concentrate each moment on a particular pairing of figures and texts. For better or worse, all my figures are men and all my texts are canonical, but the men do not look so triumphant in retrospect, and today the canon appears less as a barricade to storm than as a ruin to pick through. This condition (which need not be melancholic) distinguishes the present of art and criticism, politically and strategically, from the recent past (the past of the postmod-

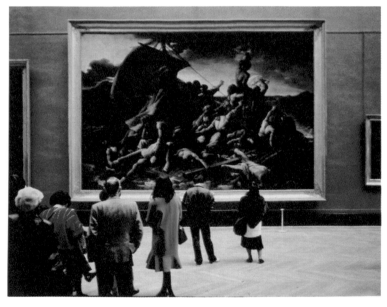

Thomas Struth, *Louvre IV*, 1989, with *The Raft of the "Medusa"* (1819) by Géricault: "memory is the great criterion of art; art is the mnemotechny of the beautiful" (Charles Baudelaire).

ernist critique of modernism), and part of my purpose is to point to this difference.

<p style="text-align:center">*</p>

My first pair in this dialectics of seeing is Baudelaire and Manet. "Memory," Baudelaire writes in his "Salon of 1846," "is the great criterion of art; art is the mnemotechny of the beautiful."[3] What he implies is that a great work in an artistic tradition must evoke the memory of major precedents in this tradition as its ground or support (for Baudelaire this meant ambitious painting after the Renaissance; he denigrated sculpture). But the work must not be overwhelmed by these precedents: it must activate the memory of such important images subliminally – draw on them, disguise them, transform them.[4] As a positive instance of this "mnemotechny of the beautiful," Baudelaire points to the persistence of Géricault's *Raft of Medusa* (1819) in Delacroix's *Barque of Dante* (1822). This kind of subtextuality of mnemonic afterimages – to be distinguished from any sort of pastiche of overt citations – is what constitutes an artistic tradition for him, almost in the etymological sense of "tradition" as a passing-on of potential meanings, and in this light memory *is* the medium of painting for Baudelaire.[5]

Two brief amendations might be added here. First, in a reversal that has become familiar ever since T. S. Eliot wrote "Tradition and the Individual Talent" (1917), these afterimages can also be retroac- tive: the *Barque* might work its way back into the *Raft* as well, that is, into mnemonic elaborations of it. In this way tradition is never given but always constructed, and always more provisionally than it appears. This provisionality has become patent to us, to the point where, if the modernists felt tradition as an oppressive burden, we are likely to feel it as an unbearable lightness of being – even though some of us continue to project a weight on to it that it no longer

has, as if we needed it as an habitual object of attachment or antagonism. Second, the model of artistic practice intimated by Baudelaire is already art-historical, as it were, and it already presumes the space of the museum as the structure of its mnemonic effects, as the place (more imaginary than real) where an artistic tradition happens. Put differently, this "mnemotechny of the beautiful" assumes an institutional relay between atelier and studio, where such transformations are made, and exhibition and museum, where they become effective for others (this relay is further mediated, of course, by the many discourses of Salon critics, review readers, caricaturists, gossips, and so on). In short, in the Baudelairean scheme, painting is an art of memory, and the museum is its architecture.[6]

Soon after this Baudelairean intervention in the mid-nineteenth-century discourse on artistic memory, Manet emerges. As Michael Fried has argued, he disturbs the Baudelairean model somewhat, as his practice pushes the subtextuality of mnemonic afterimages toward a pastiche of overt citations. More explicitly than his predecessors, Manet exposes or, better, proposes a "memory-structure" of European painting since the Renaissance, or at least one allusive cluster in this complicated text. According to Fried, Manet is overt in his citations because he aspires to subsume a post-Renaissance past in European painting – through part-for-whole allusions to French art, Spanish art, and Italian art (his relevant allusions are to Le Nain, Velázquez, and Titian among others, and his *Old Musician* [1862] is one kind of compendium of references).[7] In this way Manet produces, perhaps for the first time, the effect of a trans-European art, of a near totality of such painting – an effect that soon allowed painting to be imagined as Painting with a capital P, and later led to the association of Manet with the advent of modernist art.

One obvious test-case here is *Le Déjeuner sur l'herbe* (1863), not only in its well-known evocations of Renaissance masters like

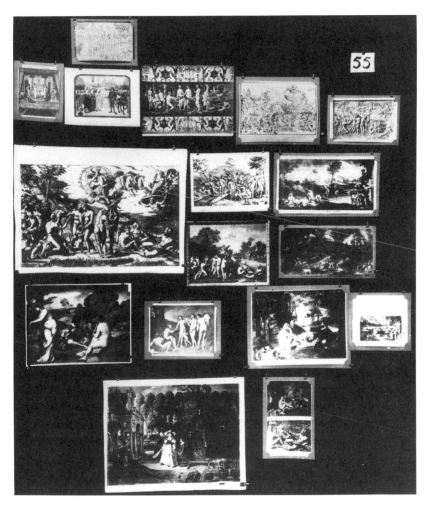

Panel 55 of the *Mnemosyne Atlas* by Aby Warburg, c. 1928–29, with *Le Déjeuner sur l'herbe* (1863) by Manet, among other images: the memory-structure of post-Renaissance painting at once glimpsed and lost.

Raphael (a detail of his lost *Judgment of Paris* is cited in the central figures by way of an engraving by Marcantonio Raimondi) but also in its unusual combination of traditional genres of painting such as the nude, still life, portraiture, and landscape, all of which are transformed into a "painting of modern life." For Fried this text of images and combination of genres create a heightened *unity* of painting that is characteristic of Manet and his followers, a unity that Fried values from the neoclassical tableau espoused by Diderot to the late-modernist abstraction achieved by Frank Stella: a unity *within* painting that promotes an autonomy *of* painting. Of course Baudelaire saw things differently: with his ambivalent homage to Manet as the first in the "decrepitude" of his art, he implies that the memory-structure of painting, its continuity as a subtextuality of afterimages, is in danger of corruption with Manet, perhaps because his citations are too explicit, too various, too "photographic."[8] However, rather than choose one reading over the other, we might reconcile the insights of both if we propose – in a manner not as paradoxical as it sounds – that the memory-structure of post-Renaissance painting is already strained at the very moment that it is somehow attained.

Let me underscore two points mentioned above: that modern art is already conceived by Baudelaire and Manet in implicitly art-historical terms, and that this conception depends on its museal setting. Again, this museum is mostly imaginary, an extended Louvre based on mnemonic traces, workshop imitations, graphic reproductions, and so on – a museum without walls before Malraux declared it so or, better, a museum with a myriad of walls, both real and fictive. And yet this memory-structure is also very limited, centered almost entirely on painting and run on a narrow geographic track (mostly Paris to Rome, with a few detours to Holland and Spain – hardly trans-European). Moreover, it is fiercely Oedipal,

built on a network of patriarchal workshops and rivalrous groups from David to Delacroix and beyond.[9] Yet it is these very limitations that make this nineteenth-century French painting – the transformations of its terms and the displacements of its desires – so effective formally, semiotically, and mnemonically.

For the most part these conditions still obtain in the model of the "Valéry Proust Museum" that Adorno locates, in his 1953 essay of that title, toward the end of the nineteenth century. Yet here, with Valéry and Proust, the next moment in this museal dialectics of seeing, we are a few decades on from Baudelaire and Manet, and the views on this museum have changed somewhat. For Adorno Valéry represents the view that the museum is where "we put the art of the past to death."[10] "Museum and mausoleum are connected by more than phonetic association," the German critic writes, as if in the voice of the French poet-critic. "Museums are like the family sepulchres of works of art. They testify to the neutralization of culture."[11] According to Adorno, this is the view of the producer of art in the studio who can only regard the museum as a place of "reification" and "chaos," and he distinguishes it from the view that Proust represents for him. In the Adornian scheme Proust begins where Valéry stops – with "the afterlife of the work" – which Proust sees from the vantage-point not of the producer of art in the studio but of the viewer of art in the museum. For the idealist viewer à la Proust the museum is a kind of phantasmagorical perfection of the studio, a spiritual place where the material messiness of artistic production is distilled away – where, in his own words, "the rooms, in their sober abstinence from all decorative detail, symbolize the inner spaces into which the artist withdraws to create the work."[12] Rather than a site of actual reification, then, the museum for Proust is a place of fantastic reanimation, indeed of spiritual idealization. And rather than a chaos of works, the museum for Proust stages

"the competition among works [which] is the test of truth" (here Adorno speaks for him).[13] This "competition" is essentially the Oedipal struggle that underwrites the memory-structure mentioned above; only it is more agonistic than the subtextuality of after-images implied by Baudelaire. In fact Proust and Valéry represent more extreme versions of the positions associated with Baudelaire and Manet: the former figure in each pair focuses on the mnemonic reanimation of "the beautiful," while the latter figure foregrounds its museal reification.

By the same token, however, the Valéry and Proust accounts of the art museum are no more opposed than the Baudelaire and Manet models of artistic memory. Rather, each of these pairs points to *a dialectic of reification and reanimation* that structures all these reflections on modern art and modern museum. As we saw, Adorno used the first notion, "reification," in relation to Valéry; he derives it, of course, from Georg Lukács, who developed it, not long after the statements of Valéry and Proust, from Marx on commodity fetishism. In his great essay "Reification and Class Consciousness" (1922) Lukács implies that spiritual reanimation of the sort urged by Baudelaire and Proust is an idealist compensation for capitalist reification; in effect reification and reanimation make up one of "the antinomies of bourgeois thought" that he details there.[14] This antinomy also permeates "the history of art as a humanistic discipline," and this is my principal implication here: that art history is born of a crisis – always tacitly assumed, some-times dramatically pronounced – of a fragmentation and reification of tradition, which the discipline is pledged to remedy through a redemptive project of reassembly and reanimation. This is not to say, as Karl Kraus once remarked of psychoanalysis, that art history is the illness of which it thinks it is the cure. The memory crises to which the discipline responds are often real enough; but pre-

cisely because they are actual, art history cannot solve them but only displace them, suspend them, or otherwise address them again and again.[15]

I want to include, in this second moment, another pair of figures, less dialectical than the others but more central to art history: Heinrich Wölfflin and Aby Warburg.[16] Like their near contemporaries Valéry and Proust, Wölfflin and Warburg inherit the archival relation associated here with Baudelaire and Manet, the one that first projected both a totality of European art and a chaos of museal fragments. In this light, this first archival moment all but demanded the sort of synthetic model-terms that these foundational art historians proposed in our second moment: I mean the diacritical "styles" of Wölfflin (the system of Classical versus Baroque attributes laid out in his *Principles of Art History* [1915] and prior texts) and the "pathos formulas" of Warburg (the emotive poses and gestures in "the afterlife of antiquity" traced in his *Mnemosyne Atlas* and various articles). More precisely, these synthetic terms (more on which in Chapter 6) emerge in such a way as to defend against the museum as a chaos of fragments in the Baudelaire–Manet moment – to defend against it in the service of a formal unity and a historical continuity that are presented as always threatened but never quite lost.[17]

In the service of unity or continuity: when Wölfflin discussed "The Why of Development" in *Principles of Art History*, this "why" might betray an anxiety that art no longer displayed a "development" of the sort that he posited in its past.[18] Warburg shared this anxiety, and both men worked it over in their art history, in a sense *as* their art history. Perhaps they hoped that the order projected there would find its way into their lives; perhaps most (art) historians do. In any case, Wölfflin published his *Principles* only in 1915, though it was finished well before, a delay that is telling, as

Martin Warnke has argued, for Wölfflin regarded his book "as a repository of sensory prewar experience," an archive of refined sensibility destined to be shattered in the Great War – in effect a memory-structure of European art transcribed for pedagogical preservation.[19] Certainly, when Wölfflin did publish his *Principles*, it was still-born epistemologically, for it did not pertain to advanced art (1915 marks the full advent of abstract painting, constructed sculpture, and readymade objects – all resistant to the terms of Wölfflinian style-discourse).[20] Again, Warburg suffered this same historical crisis, even more profoundly. As is well known, he was committed to a psychiatric institution after a mental breakdown in October 1918 (which coincided precisely with the military collapse of Germany), and, especially as a Jew, he faced the additional threat of an emergent fascism upon his recovery in 1923. Certainly "the afterlife of antiquity" would take on an entirely other significance four years after his death in 1929 with the Nazis.[21]

At this point, however, our second moment in this museal dialectics of seeing has already shaded into a third moment. Above I referred to "the history of art as a humanistic discipline." This phrase is familiar to art historians as the title of a 1940 essay in which Erwin Panofsky defines the discipline in terms that also point to a dialectic of reification and reanimation. "Archaeological research is blind and empty without aesthetic re-creation," Panofsky writes, "and aesthetic re-creation is irrational and often misguided without archaeological research. But, 'leaning against one another,' these two can support the 'system that makes sense,' that is, an historical synopsis."[22] Written in the face of fascism (which Panofsky addresses in his conclusion), this text presents the historian as humanist and vice versa, and asserts that "the humanities . . . are not faced by the task of arresting what otherwise would slip away, but of enlivening what otherwise would remain dead."[23] This too is

an idealist credo: just as Proust wanted the studio reanimated in the museum, its materials sublimated there, Panofsky wants the past reanimated in art history, its fragments redeemed there. This idealist position must then be counterposed to the materialist position of a Benjamin, who, in his "Theses on the Philosophy of History," also written in 1940 in the face of fascism, all but inverts the Panofskyan formulation: "To articulate the past historically does not mean to recognize it 'the way it really was'," Benjamin writes. "It means to seize hold of a memory as it flashes up at a moment of danger."[24] Rather than reanimate and reorder tradition, Benjamin urges that its fragments be emancipated "from its parasitical dependence on ritual" and pledged to the present purposes of politics (as he puts it, famously, in his 1936 essay on "The Work of Art in the Age of Mechanical Reproduction").[25]

In this way, if Panofsky attempts to *resolve* the dialectic of reification and reanimation in favor of reanimation, Benjamin seeks to *exacerbate* this same dialectic in favor of reification, or rather in favor of a communist condition posited on the other side of reification. Many leftists in the 1920s and 1930s (Gramsci prominent among them) took up this call to fight through "the murky reason" of capitalism, which, Siegfried Kracauer argued in "The Mass Ornament" (1927), "rationalizes not too much but rather *too little*."[26] Through the "Artwork" essay Benjamin holds to this "left-Fordist" line as well: the shattering of tradition, advanced by mechanical reproduction and mass production, is both destructive and constructive; or, rather, it is initially destructive and so potentially constructive. At this time Benjamin still had a vision of this potential construction – the Constructivist experiments in the Soviet Union – which would sweep away the fragments of the old bourgeois culture or reassemble them, radically, in a new proletarian culture. But with the Stalinist suppression of the avant-garde in the early 1930s this

mirage had already evaporated, and Benjamin never reached the other side of reification. What seemed imminent in his "The Author as Producer" (1934) had become utopian only four years later in his "Theses on the Philosophy of History." Like the allegorical figure of this essay, the *Angelus Novus* drawn by Paul Klee and owned by Benjamin, he feels the winds of modernity in his wings, but they have turned foul: "His eyes are staring, his mouth is open, his wings are spread. This is how one pictures the angel of history. His face is turned toward the past. Where we perceive a chain of events, he sees one single catastrophe which keeps piling wreckage upon wreckage and hurls it in front of his feet."[27]

<div align="center">＊</div>

So far I have posited three different archival relations among modern art practice, art museum, and art history in three different historical moments: the first associated with Baudelaire and Manet in the mid-nineteenth century, the second with Proust and Valéry at the turn of the twentieth century, the third with Panofsky and Benjamin on the eve of World War II. In different ways the first figure in each pair projects a totality of art, which the second figure reveals, consciously or not, to be made up of fragments alone. Again, for Benjamin the principal agent of this fragmentation is mechanical reproduction: in his "Artwork" essay it strips art of context, shatters its tradition, and liquidates its aura. Even as it allows the museum a new totality, it also dooms it, and cinema advances to supplant it culturally. In this way the "cult value" of art is eradicated, and replaced by the "exhibition value" of art, its making for the market and the museum. But, at least potentially, this value is also challenged, and in lieu of these rituals, both old and new, Benjamin advocates a political refunctioning of art. Such is his dialectical account of the second archival relation as

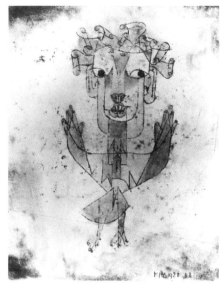

Paul Klee, *Angelus Novus*, 1920:
"Where we perceive a chain of
events, he sees one single
catastrophe . . ." (Walter
Benjamin).

it passes into a third, an account that demonstrates how each
archival shift is both enabling and disabling, transgressing and
trumping.

 Yet this account was disputed, directly and not, by other voices.
I mentioned Panofsky, but Malraux may be more pertinent here,
for he was in dialogue with Benjamin at the time of the "Artwork"
essay, which was important to his initial sketch of the *musée
imaginaire*.[28] Malraux glimpsed the same archival transformation as
Benjamin, but he drew different conclusions. For Malraux mechan-
ical reproduction not only erodes originality; it can also locate it,
even construct it.[29] And though the reproduced art work loses some
of its properties as an object, by the same token it gains other
properties, such as "the utmost significance as to style."[30] In short,

where Benjamin saw a definitive rupture of the museum forced by mechanical reproduction, Malraux saw its indefinite expansion. Where for Benjamin mechanical reproduction shatters tradition and liquidates aura, for Malraux it provides the means to reassemble the broken bits of tradition into one meta-tradition of global styles – a new Museum without Walls whose subject is the Family of Man. Indeed, for Malraux it is the very flow of a liquidated aura that allows all the fragments to course together in the River of History, or what he calls "the persisting life of certain forms, emerging ever and again like spectres from the past."[31] Here the reified family sepulchres in the museum of Valéry become the reanimated kindred spirits in the museum of Malraux. Here too the angel of history-as-catastrophe imagined by Benjamin becomes the technocratic humanist embodied in Malraux who works to recoup local crises for global continuities, to transform imagistic chaos into museological order.

Of course there are other critical voices to add in this third moment, and I have not touched on the myriad modernist practices supported by it. Clearly, too, there is a fourth archival relation to consider, one that emerges with consumer society after World War II, to be registered in different ways by the Independent Group in England, the Situationists in France, and artists like Rauschenberg and Warhol in the United States, and Gerhard Richter and Sigmar Polke in Germany.[32] But the question I want to pose here in this synoptic account concerns our own present: is there yet another archival relation, a fifth moment in this dialectics of seeing, allowed by electronic information? If so, does it shatter tradition and liquidate aura all the more, à la Benjamin on mechanical reproduction, or, on the contrary, does it permit the finding of ever more stylistic affinities, the fostering of ever more artistic values, à la Malraux on the *musée imaginaire*? Or does it render this opposition,

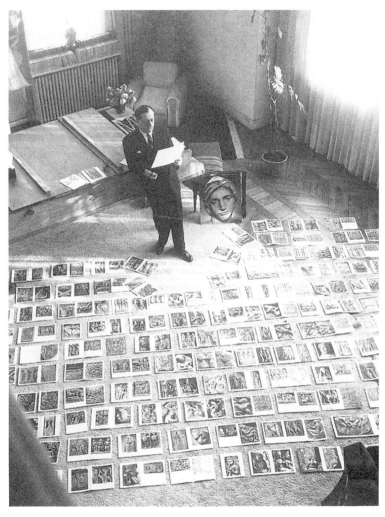

André Malraux with photographs for *The Voices of Silence*, c. 1950: history-as-catastrophe recouped as a story of stylistic connections.

all these terms, this entire dialectic, somehow outmoded and defunct? What cultural epistemology might a digital reordering underwrite for art practice, art museum, and art history alike?

I have no conclusions at this point. In some ways the dialectic of reification and reanimation continues, and with greater intensity than before. On the one hand, as a digital reordering transforms artifacts into information, it seems to fragment the object and to dissolve its aura absolutely. On the other hand, any dissolution of aura only increases our demand for it, or fabrication of it, in a compensatory projection that is now very familiar. As new aura is difficult to produce, established aura skyrockets in value (as Rem Koolhaas once remarked, there is just not enough past to go around). Thus, in an electronic continuation of the Mona Lisa Syndrome whereby the cliché only heightens the cult, the art work might become more auratic, not less, as it becomes more simulacral in the electronic archive. A version of this compensatory projection is now part of the common rhetoric of the art museum: the electronic archive does not deflect from the museal object, we are told, much less supplant it; it is pledged to lead us back to the art work and to enhance its aura. And, at least at the operational level, this archive does not conflict with the basic protocol of art history, for both are iconographic in bias; in this way at least, both are pledged to the referentiality of the object.

But let me end on another tack, and return once more to our first archival relation. Foucault also associated this moment with Manet and the museum (as well as Flaubert and the library) in this well-known formulation: "every painting now belongs within the squared and massive surface of painting and all literary works are confined to the indefinite murmur of words."[33] In many ways this "squared and massive surface of painting" is sublated – transgressed and trumped – in the Museum without Walls, and for Foucault as

for Malraux the basis of this imaginary museum of modern art is discursive: it is all but created by *ideas* – the ideas of Style, Art, and Museum. Benjamin is not content with this discursive account alone, as he foregrounds the material role not only of photographic reproduction but of "exhibition value." By this term he means exchange value as it penetrates the institution of art, and transforms both the art work and its contextual frames. Of course this transformation was explored by various movements in his own present, our third archival moment. Consider the Bauhaus in this regard. In its project to transform the art work, the Bauhaus contested the archival relations of painting and museum that obtained in our first two archival moments; yet this contestation also facilitated "the practical extension of the system of exchange value to the whole domain of signs, forms and objects."[34] Thus the Bauhaus transgressed the old orders of art, but as it did so it also promoted the new sovereignty of capitalist design, the new political economy of the commodified sign. And one insistence of this book is that this political economy now dominates social and cultural institutions.[35]

Some aspects of this historical transformation are familiar to us, such as the imbrication of modern art with the display of commodities from its beginnings (with the museum flanked by the industrial exposition on one side and the department store on the other), or the conformity of modern art, with its categories of discrete objects made for display and purchase, to exhibition and exchange values. But there are more recent developments to consider, such as the way that exhibition-value in art has become all but autonomous, to the point where it overwhelms whatever is on view. Design and display in the service of exhibition and exchange values are foregrounded as never before: today what the museum exhibits above all else is its own spectacle-value – that is the principal point of attraction and the chief object of reverence (see Chapter 3). Among

many other effects there is this one: if the old museum, as imagined from Baudelaire through Proust and beyond, was the site for the mnemonic reanimation of visual art, the new museum tends to split the mnemonic from the visual. More and more the mnemonic function of the museum is given over to the electronic archive, which might be accessed almost anywhere, while the visual experience is given over not only to the exhibition-form but to the museum-building as spectacle – that is, as an image to be circulated in the media in the service of brand equity and cultural capital. This image may be the primary form of public art today.

SIX

ANTINOMIES IN ART HISTORY

In this chapter I turn from the vicissitudes of the art museum to those of art history. What were the preconditions of this discipline at the end of the nineteenth century, and what are its preoccupations today? Are there particular contradictions that drove its formulations regarding art then, and others that guide its accounts of visual culture now?

In 1928 the Russian theorists Mikhail Bakhtin and Pavel Medvedev published an essay on "the formal method in European art scholarship."[1] There they associated the development of art history as an academic discipline at the end of the nineteenth century with the development of modernist art as an autonomous activity during the same period. In particular they related two aspects of the new discipline to two attributes of the new art: its foregrounding of "the constructive aspect" of the art work (i.e., its abstract structure) and

its attention to "alien art" in an imperialist age (i.e., its interest in exotic art – Japanese, African, etc.). Indirectly, Bakhtin argues, the first attribute helped to orient the new discipline to formalist questions of style, as in the work of Heinrich Wölfflin, and the second to different artistic wills or *Kunstwollens* of different periods and cultures, as with Alois Riegl.[2]

In this account of "West European formalism," then, art history and modernist art are not opposed, certainly not regarding the principle of aesthetic autonomy. The foremost American legatee of this formalist tradition insisted on this counterintuitive point again and again: "Modernism," Clement Greenberg wrote in 1961, "has never meant anything like a break with the past."[3] By this time, however, the principle of aesthetic autonomy had largely narrowed to the protocol of medium-specificity (i.e., that painting is painting and nothing else), a narrowing that was very effective institutionally. For through a sharing of this protocol, art practice, art museum, and art history alike could agree on parameters for the proper making, exhibiting, and narrating of modernist art. No doubt the museum was first among equals here, for it provided the institutional illusion of autonomy that the other two parties required. In *The Voices of Silence* (1951) Malraux opens his discussion of "the museum without walls" with this celebration of the museal transformation of diverse things into formal mediums: "A Romanesque crucifix was not regarded by its contemporaries as a work of sculpture; nor Cimabue's *Madonna* as a picture. Even Pheidias's *Pallas Athene* was not, primarily, a statue"[4] Only the museum could elevate such different object-functions to the art-status of painting and sculpture alone – an elevation that was well suited to the abstraction of modernist art.

Often the protocol of medium-specificity in modernist art aspired to an ontology of all art: painting and sculpture were

thought to possess an essential nature that art practice, art museum, and art history might disclose, each in its own way. Where once this ontological assumption offered all three parties a coherent way of working, it has not done so for some time now.[5] Due to artistic transgressions, theoretical critiques, political demands, and techno-logical pressures (some sketched in Chapter 5), these old institu-tional arrangements have broken down. Not only has the practice of modernist art fallen into ruins, but so too have the protocols of art museum and art history that attended it.

Of course it was not only "constructive" art that inclined art history to the principle of autonomy (prominent scholars like Wölfflin were mostly suspicious of modernist practice); there was also the philosophical imperative of Kantian self-critique (revived at the time in neo-Kantianism). And it was not only "alien" art that disposed the new discipline to a narrative of different artistic wills or *Kunstwollens*; there was also the philosophical model of Hegelian history, its account of the symbolic expressions of different cultures. These two motives guided the foundational figures of art history in the late nineteenth and early twentieth centuries in two principal tasks: on the one hand to demonstrate the autonomy of art, on the other to connect it to social history.[6] Obviously both operations were crucial to the new discipline – the Kantian to distinguish art from other kinds of expression, the Hegelian to historicize it – but just as obviously the two operations were in tension, and this tension has run through the discipline like a fault-line.

On this fault-line art history seems contradictory, even oxymo-ronic: how can art be both autonomous in form and imbricated in social history? In *Principles of Art History* (1915) Wölfflin simply split the opposition: style has a "double root," he claimed; an extrinsic one determined by individual and national character, and an intrinsic one driven by perceptual and formal pressures. Thereafter formalist

critics like Greenberg tended to fold the extrinsic root into the intrinsic one, and to argue that, in the first instance, art constituted its own history. Yet, as this response resolved the opposition in favor of the autonomous term alone, it was no resolution – which is also true of responses that favored the social–historical term alone (as with the work of Arnold Hauser, say). Many important concepts developed in art history – such as the *Kunstwollens* of Riegl and the "symbolic forms" of Erwin Panofsky – were also concerned to reconcile the opposition between formal autonomy and social–historical imbrication. More recently art historians and critics have appealed to other discourses, semiotics above all, to ease this tension. Yet, however useful, the terms developed to this end have tended to be metaphorical or tendentious or both.

In his introduction to the work of the French anthropologist Marcel Mauss, Claude Lévi-Strauss reflects on such terms in critical discourse. There he speculates that language arose all at once, in an explosion of signification – a kind of semiotic Big Bang that left a surplus of signifiers for all time. "There is always a non-equivalence or 'inadequation'" between signifier and signified, Lévi-Strauss writes, and "every mythic and aesthetic invention" works to cover over this "non-fit," to soak up this "overspill."[7] His prime example of such invention is the term *mana*, the secret power that, according to Mauss in his great essay on gift exchange, *Essai sur le don* (1925), certain indigenous people ascribed to certain exchange items. Yet, Lévi-Strauss insists, this term has primitive force only for Mauss: the semiotic "overspill" and semantic soaking-up occur only in his text; the magical thinking here is his. And Mauss is hardly alone: all critical discourse has its *mana* terms, its "floating signifiers," its magical words.

Where do these terms appear, and what magic do they work? "Somewhat like algebraic symbols," Lévi-Strauss tells us, they "rep-

resent an indeterminate value of signification."[8] Most often in art history this "indeterminate value" concerns the "signification" of context; hence its *mana* terms tend to point to social connection and historical causation – they are often verbs (like "reflect" or "embody") that point to these determinations but do not explain them. Perhaps this problem is basic to any discourse concerned with such determinations, or that constructs its object in oppositions of text and context, object and frame, inside and outside.[9] What historian or critic does not have such a fetish word, a favorite term where, as in a black box, such mediations only appear to happen? But it is especially marked in art history because of its simultaneous claiming of formal autonomy and social–historical imbrication. Many concepts, often as productive as they are problematic, have risen out of this contradiction, and most feature *mana* terms.

Consider *Kunstwollen* in this regard. Riegl advanced the concept in the interests of aesthetic autonomy against the claims of material determination made by the followers of the architectural historian Gottfried Semper: where they had argued the fundamental nature of technical *skill*, he argued the relative independence of artistic *will*. Yet for Riegl this will was not only about artistic form; it also expressed the distinctive character of its period and/or culture. In a 1920 essay Panofsky objected, rightly, that *Kunstwollen* psychologized art; yet this was one of its implicit purposes: to ease the antinomy between formal autonomy and social–historical imbrication through a cultural psychology, the ascription of a "will" to a period and/or culture.[10] Moreover, Panofsky substituted a concept that did much the same thing. Although concerned with conceptual structures rather than expressive wills, his idea of "symbolic form" also worked to reconcile formal autonomy and social–historical imbrication; in effect, where Riegl endowed a period and/or culture with a volition, Panofsky gave it a mentality.[11] And these two *mana* terms are among the most

sophisticated in art history; others, such as the "modes of vision" proposed by Wölfflin, are more brutal. On the one hand, Wölfflin defines these modes, through his master opposition of Classical versus Baroque styles, as radically diacritical (the Classical is relatively linear, open, clear, the Baroque relatively painterly, closed, obscure). On the other hand, on the first page of *Principles of Art History*, he is even more radically referential: "every painter paints 'with his blood'."[12] Here, notwithstanding the distance carved out by the scare quotes, Wölfflin collapses formal autonomy and social–historical imbrication through a racialist invocation of a folkish mind–body. And this psychobiology, which is at once reductive and totalistic, returns in art history whenever tribal terms like "Gothic" and geocultural oppositions of North and South, East and West, are used in the old ways. That is to say, it never goes away, so deeply inscribed are these notions in our courses and texts, exhibitions and museums.[13]

Certainly, in the wake of postcolonial discourse, art historians are more self-aware on this score. Yet the antinomies in the discipline have not disappeared, and so the *mana* terms have not either. Important texts of the last three decades that have extended the history of art to visual culture are also not free of such signifiers. In *Painting and Experience in Fifteenth-Century Italy* (1972), an inaugural work in this discourse, Michael Baxandall uses tropes like "period eye" and "cognitive style" that still evoke a cultural mind. However, he does so in order to *undo* the opposition of formal autonomy and social–historical imbrication: emphasis falls on the mediations between "painting and experience," "visual skills" and "social facts."[14] Most often Baxandall sees these relations as dialogical relays; yet sometimes he figures them in passive ways, as in the geological trope that opens his book – "a fifteenth-century painting is the deposit of a social relationship" – or in the paleontological trope that soon follows – "paintings are among other things fossils of economic

life."[15] Again, such analogies are somewhat magical – though, as Paul de Man often insisted, they may be so rooted in language that, were we to dig them out somehow, there might not be much left.

More recent studies of visual culture eschew the generality of a cultural mind for the specificity of historical spectatorship; I have in mind such signal texts as *The Art of Describing* (1983) by Svetlana Alpers, *Body Criticism* (1991) by Barbara Maria Stafford, and *Techniques of the Observer* (1990) by Jonathan Crary. Under theoretical influences that range from Lacan and Althusser, to Foucault and new historicism, to Raymond Williams and cultural studies, such texts present historical viewers as social constructions. As constructed, they are specific, indeed singular, and there are no vague abstractions of *Kunstwollens* or symbolic forms; yet these subjects are also presented as so determined by the social as to be flooded by it, one with it – *Zeitgeists*-in-person, as it were.[16] Here it is the subject, not the art, that becomes the "deposit of a social relationship," and often it is the principal object of analysis as well. Paradoxically, then, this historically specific subject becomes generally consistent, broadly representative of its period and/or culture, and so we are offered portraits, often brilliant, of *the* seventeenth-century Dutch viewer, *the* eighteenth-century Enlightenment spectator, *the* nineteenth-century European observer, and so on. If the painter in the old art history once painted "with his blood," the viewer in this new art history observes "as constructed to do so," and it is this subject that provides discursive consistency (as it has for some time now in literary studies influenced by "new historicism"). Here, then, the partial shift from the old art history to the new is marked by a partial shift in object – away from histories of style and analyses of form toward *genealogies of the subject*.[17]

*

So far I have touched on visual studies as it emerged from art history, but most of this work is concerned with more recent visual culture. In this sense "visual studies" represents a wide array of criticism that draws on film theory and media analysis; in effect it is the visual wing of "cultural studies," the study of popular and subcultural forms of expression, and its topics range from movies, television, and the Internet to visual representations in medicine, the military, and other sciences and industries. "Visual culture," then, represents our contemporary world of heightened spectacle pervaded by visual commodities and technologies, information and entertainment.[18] As a social description this seems clear enough: the image dominates our society perhaps as never before. As an academic subject, however, "visual culture" is less clear, and maybe as oxymoronic as "art history." Certainly its two terms repel each other with equal force, for if art history is strained between the autonomy implied in "art" and the imbrication implied in "history," then visual culture is stretched between the virtuality implied in "visual" and the materiality implied in "culture." One way to draw out the implications of this shift is to consider these substitutions further.

The turn from "history" to "culture" suggests a new affiliation with *anthropology* as a guardian discourse. Art history was also affiliated with anthropology in the late nineteenth century; historically the relation between the two disciplines resembles a sibling rivalry, with periods of intimacy followed by times of disconnection. Some foundational figures of art history redefined artistic production in anthropological terms: Riegl through his involvement in lowly forms like textile ornament and marginal fields like the late Roman art industry, Aby Warburg through his notion of art as "document" and his study of Pueblo Indian rituals and early Renaissance cosmologies. As noted in Chapter 5, these two figures have attracted much attention lately, which suggests a revived interest in this

anthropological dimension of the discipline.[19] Yet the immediate source of the ethnographic model in visual studies remains cultural studies. Over the last two decades cultural studies has investigated texts and images long shunned by scholars, and so challenged hierarchies of high and low culture and major and minor forms. This challenge to elitist canons has brought great gains; but the shift from art history to "image history," as proposed by various advocates of visual studies, might have some costs as well.[20] In general terms visual studies might be too quick to dismiss aesthetic autonomy as retrograde, and to embrace subcultural forms as subversive. Its ethnographic model might also have this unintended consequence: it might be encouraged to move horizontally from subject to subject across social space, more so than vertically along the historical lines of a particular form, genre or problematic. In this way visual studies might privilege the present excessively, and so might support rather than stem the posthistorical attitude that has become the default position of so much artistic, critical, and curatorial practice today.[21]

The ethnographic turn is general to cultural studies, visual and other, and it is important to understand why. Again, anthropology studies culture, and postmodernist practice has long claimed this expanded field as its own. Second, anthropology is contextual, another important value for contemporary artists and critics, many of whom conceive projects as fieldwork in everyday life. Third, anthropology addresses alterity, and along with psychoanalysis this has made it a lingua franca of much recent art and theory. Fourth, anthropology seems to arbitrate the interdisciplinary, which renders it a court of appeals for disciplinary disputes. And finally, fifth, the self-critique of anthropology makes it attractive (I mean the recent work of James Clifford, George Marcus, and others), for it promises a reflexivity of the ethnographer even as it preserves an alterity of the other.

Yet, epistemologically speaking, the ethnographic turn over the last two decades may be clinched by another factor. According to Marshall Sahlins, two models have long divided anthropology: one stresses "symbolic logic," with society seen in terms of exchange systems; the other privileges "practical reason," with society seen in terms of material culture.[22] In this light anthropology already participates in the two contradictory models that have divided so much recent art and criticism. On the one hand, it participates in the old model of *textuality*, which, in the hands of structuralists, reconfigured society as a symbolic order or a cultural system and, in the hands of poststructuralists, conjured up "the death of the author" and "the dissolution of man." On the other hand, it also participates in the new longing for *referentiality*, for a grounding in identity and community, which has led many artists and critics to reject the old text models and subject critiques altogether. With a turn to the already-split discourse of anthropology, then, artists and critics can resolve these contradictory models magically: they can take up the roles of both cultural semiologist and contextual fieldworker; they can continue and condemn critical theory simultaneously; they can perform subject critiques and identity politics at the same time. For these reasons, in our extended period of theoretical ambivalences and political impasses, anthropology remains the compromise discourse of choice.[23]

Just as social imperatives and anthropological assumptions have governed the shift from "history" to "culture," so technological imperatives and psychoanalytic assumptions have governed the shift from "art" to "visual." Here "the image" is to visual studies what "the text" was to poststructuralist criticism: an analytical tool that has revealed the cultural artifact in new ways, especially regarding the psychological positionings of different viewers, but sometimes to the neglect of its historical formation. For often in visual studies

that develops out of film theory and media studies, the image is treated as a projection – in the psychological register of the imaginary, in the technological register of the simulacral, or both – that is, as a doubly immaterial fantasm. Moreover, where once critics were slow to concede the importance of the image in our political economy, perhaps today they are too quick to grant it a dominance that it does not possess.[24]

This imagistic turn seems to contradict the ethnographic turn discussed above. Perhaps, as followers of Kant and Hegel once wrestled for the philosophical soul of art history, so psychoanalysis and anthropology now vie for the theoretical heart of visual studies. Yet this new struggle might soon be overwhelmed by more worldly forces. In this regard consider how Barbara Stafford argues, in *Body Criticism*, for a visual studies attentive to the equal rights of the image.[25] She insists, rightly, that Platonic philosophy long degraded the image as bodily and feminine, that old biases against the image persist (Puritanical suspicion of its pleasures, Enlightenment suspicion of its deceptions, and so on), and that the humanities remain rooted in literary protocols (philological, exegetical, rhetorical, hermeneutic, deconstructive). Yet this critical suspicion of the verbal humanities leads her to an uncritical celebration of visual culture. "The task at hand," Stafford writes in *Good Looking* (1996), is to abandon "deconstructive autopsy" and to demonstrate "the historical virtues of visualization for the emergent era of computerism."[26] In this embrace of virtuality (or what she calls "the aesthetics of almost"), painting, sculpture, "linear sentences" – any practice not "consonant with an era of insubstantial and endlessly variable transformations" – seems destined for the historical dustbin. For all its provocative enthusiasm, this call for a "new pedagogy" of "visual aptitude" betrays a profound anxiety about the continued relevance of art history, indeed of the humanities in general.[27] Of course terms

like "literacy" and "aptitude" are deeply ideological; and along with "digital literacy" "visual aptitude" is a primary version of this ideology in our present, with potential losses as well as gains at every level of education and research.

<div align="center">*</div>

I began with the interest, in art history and modernist art at the end of the nineteenth century, both in "the constructive aspect" of art and in "alien" forms of culture. Might the discourse of visual culture today depend on two parallel preconditions – on the virtuality of visual media and on the multiplicity of postcolonial culture? A third parallel might be proposed straightaway. Art history then relied on techniques of photographic reproduction to abstract a wide range of *objects* into various systems of *style* – as defined in diacritical terms by Wölfflin in *Principles of Art History*, or in cross-cultural affinities by Malraux in *The Voices of Silence*. Might visual culture now rely on techniques of electronic information to transform a wide range of *mediums* into various systems of *image-text* – into a digital database without walls, an electronic archive beyond museums? The discursive effects of photographic reproduction on artistic culture were not thought through until the late 1920s and 1930s. How long will it take us to work out the institutional implications of electronic information?[28]

Perhaps another historical juxtaposition might help here – a model of the subject in a different kind of archive or order of images. In "The Age of the World Picture" (1938) Heidegger related the rise of the Renaissance subject to the (re)discovery of perspective. Indeed he defined this new humanist subject almost as a function of this new "world picture":

> The interweaving of these two events, which for the modern age
> is decisive – that the world is transformed into picture and man

into *subiectum* – throws light at the same time on the grounding event of modern history, an event that at first glance seems almost absurd. Namely, the more extensively and the more effectually the world stands at man's disposal as conquered, and the more objectively the object appears, all the more subjectively, i.e., all the more importunately, does the *subiectum* rise up, and all the more impetuously, too, do observation of and teaching about the world change into a doctrine of man, into anthropology. It is no wonder that humanism first arises where the world becomes picture.[29]

Perhaps the new subject of "the era of computerism" descends from this old humanist subject, but if so its will to mastery may be pushed to an inhuman point – to the point, that is, where the humanism of the world-become-picture is reversed into an inhumanism of the world-become-information. For in the virtuality of the electronic archive, according to Mario Perniola, "what is real is not what appears at any moment, but what is conserved in memory," and this memory is "external to the spirit, to the actuality of its acquisition of consciousness":

If effectual reality is no longer conceived as actual (as in the metaphysical tradition that survived until the advent of mass-media society), but as virtual (as in the society of information technology), the entire humanist world vision that conferred upon the subject its ontological meaning collapses ... What is essential does not issue from the inwardness of the soul, but from the outwardness of writing, of the book, of the computer.[30]

My purpose here is not to mourn the "inwardness of the soul" (as Perniola seems to do) any more than to celebrate the "outwardness of the computer." As for the latter, "the era of computerism" has already produced its own suspect myths – myths of community and

globality, of access and interactivity.[31] At the same time it has also projected new sorts of spaces and subject positions – certainly ones different from those of "the age of the world picture."

Here again I have only impressions to offer. First, however digital in operation, this new world is still visual in appearance, as its language of "screens," "windows," and "interfaces" underscores. The screen remains the dominant modality of the electronic archive, but what kind of image is it exactly? Clearly it differs radically from

Anonymous central Italian artist, *View of an Ideal City*, c. 1490–1500: "the more objectively the object appears, all the more importunately does the subject rise up" (Martin Heidegger).

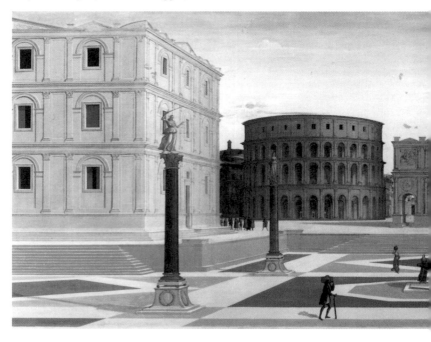

the pictorial tableau of painting, but it also diverges from the projected image of cinema as well as the broadcast image of television. (In some ways it retains the problematic aspects of both mediums: the fascination of viewers as in film, the separation of viewers as in television.) A luminous scrim of information, it arises from elsewhere, on command like a genie, to be manipulated at will. But what one manipulates on the screen is *data* (Latin for "given"), which suggests that we do not produce this information so much as we manipulate its given-ness. This has two different ramifications for two different publics.

For the initiate public the computer is the ultimate instrument

of "computability," and this operation, which is also a value, has become pervasive. Finance capital has flowed to two sites above all others, technology and biology, and especially to convergences of the two, such as ventures concerning the human genome.[32] More and more technology and biology are understood as information, as media, and this understanding supports the model of computability of all life in these terms. Here the goal seems to be the total transparency of this information, the total transformability of this data (a potential Taylorism of the gene). For the noninitiate public the situation is quite different: rather than the ultimate instrument of manipulability, the computer is the ultimate black box where production (or is it "signification"?) is occluded – perhaps occluded *as* information. In some respects the computer gives the subject enormous control, in a great upgrading of "the world picture" put at our "disposal as conquered." In other respects, however, its operations are so auto-generative as to be oblivious to the subject, who thus occupies "an ambiguous and unfixed location" in relation to the computer.[33]

If the place of the subject is ambiguous in the electronic archive, so is its tabulation of things. Again, a fundamental operation of this archive is the transformation not only of particular objects but of entire mediums into image-texts; all sorts of sites are turned into information-pixels.[34] In 1966, before "the era of computerism" was understood as such, Foucault was prompted to consider different tabulations of "words and things." *The Order of Things* begins, famously, with a "certain Chinese encyclopedia" imagined by Jorge Luis Borges, an absurd list of monstrous animals that disrupts "the age-old distinction between the Same and the Other."[35] From this list Foucault generates an allegory about a catastrophe in the very allegorical structure of knowledge, that is, of words related to things in a spatial system. Here, he implies,

even the emblematic objects of Surrealist collage – "the umbrella" and "the sewing-machine" – had lost "the operating table" that allowed them to come together, in a chance encounter, in the first place. "What is impossible," Foucault writes of the Borgesian encyclopedia, "is not the propinquity of the things listed, but the very site on which their propinquity would be possible."[36] Now, for all appearances, this Borgesian disorder has become our order, this post-Surrealist heterotopia is our topos. After photographic reproduction the museum was no longer so bound by walls, but it was still organized by style. What is the limit of the archive beyond

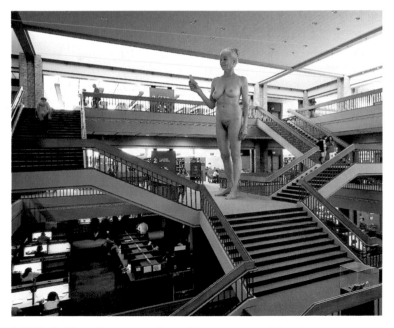

Jeff Wall, *The Giant*, 1992: the subject empowered by the computer or placed in "an ambiguous and unfixed location"?

museums? Like any archival shift, this one both liberates and con-
strains – perhaps at the same time. Perhaps for all its apparent
mobility of signs there is an actual stasis of system here. Perhaps
the museum and the library have returned, recombined in a new
Alexandria, an electronic box in which other "orders of things" are
melted down: an entropic archive.[37]

*

Secretly or otherwise, all discourses either mirror or model a sub-
ject. This is clear enough in aesthetics, concerned as it traditionally
is with proper judgment, refinement, and taste, but art history is
not very different in this regard. Certainly, to proclaim the auton-
omy of the art *object*, as both aesthetics and art history often
do, is to presuppose or to project an autonomy of the art *subject*,
and on this point – that art might reconcile opposed faculties and
so demonstrate a freedom of mind – Kantian and Hegelian tra-
ditions in both disciplines have agreed.[38] Of course this self-fash-
ioning can be forced, rigid, moralistic. "The only means of access
to art work remains exaltation, i.e., a feeling of moral obligation,"
Benjamin wrote of a disastrous experience of a Wölfflin lecture in
1915. "He does not see the art work, he feels obliged to see it,
demands that one see it, considers his theory a moral act; he
becomes pedantic, ludicrously catatonic, and thereby destroys any
natural talents that his audience may have."[39] But this moral act
can also enliven rather than embalm the subject, or so formalists
have often claimed, as Michael Fried did fifty years after Benjamin
condemned Wölfflin:

> While modernist painting has increasingly divorced itself from
> the concerns of the society in which it precariously flourishes,
> the actual dialectic by which it is made has taken on more and

more of the denseness, structure and complexity of moral experience – that is, of life itself, but life as few are inclined to live it: in a state of continuous intellectual and moral alertness.[40]

What sort of subject does visual culture mirror or model? Not an autonomous subject, for good or for bad; instead the subject is understood as a kind of image: this axiom has passed from theories in psychoanalysis (where the foundational act of our identity is an imaginary mimesis, an identification with an image) into everyday behavior in the culture at large.[41] At the same time the reverse is true as well: the image is defined as a kind of subject with desires of its own.[42] Neither development is particularly new. For example, this equation of subject and image is isomorphic with the structure of commodity fetishism as outlined by Marx in *Capital*, but this fetishism has received a great upgrade in the present. In the capitalist divorce of producer from product, Marx argued, the relation between people takes on "the fantastic form of a relation between things," and inanimate things take on the even more fantastic form of human agents – a confusion that he associated with "the misty realm of religion" where "the products of the human brain appear as autonomous figures endowed with a life of their own."[43] This confusion, which Marx figured as a *visual* projection, indeed as an imaginary misrecognition, is so deep in the image fetishism of visual culture that we rarely notice it. Not only does this new fetishism obscure productive relations and material conditions like the old, but it also renders this confusion more internal to the subject, almost constitutive of it. This fetishistic image-anthropomorphism drives many discourses today: no longer just friendly, computers are interactive; not just communication, the Internet offers interconnectivity; and so on. Today the "pathetic fallacy," the projection of the human into the nonhuman, approaches a

technological reality, and here too the reverse must be considered as well: a "technological fallacy" whereby the machine projects its modalities into the subject.

For many of us "autonomy" is a bad word – a ruse in aesthetic discourse, a deception in ego psychology, and so on. We forget that autonomy is a diacritical term like any other, defined in relation to its opposite, that is, to subjection. Historically this subjection was often figured in the primitivist terms of fetishism. In the Enlightenment the irrational fetishist (a fantasm almost always projected to Africa) was an important foil for the rational European: in many ways the autonomy of the latter depended on the subjection of the former.[44] Explicitly in *Du culte des dieux fétiches* (1760) Charles de Brosses defined fetishism as "an infantile cult" that traps its worshippers in a "perpetual childhood"; and implicitly in "What Is Enlightenment?" (1784) Kant presented fetishism as the secret epitome of "the self-incurred tutelage" to be vanquished by the Enlightenment.[45] Marx was part of this same Enlightenment project: his critique of commodity fetishism was also made in the name of autonomy, as was the Freudian critique of sexual fetishism (though Freud knew it could not be vanquished). As given to us by the Enlightenment, aesthetic autonomy is secretly articulated against fetishistic enslavement as well: the orderly austerity of the Kantian art work is opposed to the sensuous seduction of the fetish, the disembodied disinterest of the Kantian viewer to the embodied desire of the fetish worshipper, the sublimation of Kantian object and subject alike to the perversion of fetish and fetishist alike.

In the 1920s artists and critics often seized the fetish to challenge this aesthetics of automomy. For example, if Marx once described fetishism as "the religion of sensuous desire," Surrealism aimed to be this religion in art: it sought to inject desire into the aesthetic, to bind subject to object fetishistically, and to this end it modeled the

art work as a sexual part-object rather than an ideal body-ego. Not cognitive disinterest but libidinal investment was the new goal of aesthetic appreciation: "I dare any amateur of painting," Georges Bataille once wrote, "to love a picture as much as a fetishist loves a shoe."[46] But the problem with this anti-aesthetics of the fetish today is that this dissident position in modernism has become a dominant position in postmodernism. There is no tradition of autonomy to subvert; in many ways our tradition – our world – has become quasi-Surrealist (or, as suggested above, post-Surrealist), and the exploitation of the unconscious is hardly the project of artists alone.[47]

Again, autonomy is a bad word for many of us. We tend to forget that it is always situated politically. Enlightenment thinkers proclaimed autonomy in order to wrest institutions away from the *ancien régime*; art historians like Riegl proclaimed autonomy in resistance to reductive accounts of art; modernists from Manet to the Minimalists proclaimed it to challenge the priority of iconographic texts, the necessity of illustrational meanings, the imperialism of mass media, or the overburdening of art with voluntaristic politics. Like essentialism, autonomy is a bad word, but it may not always be a bad strategy: call it strategic autonomy.

ART CRITICS IN EXTREMIS

The art critic is an endangered species. In cultural reviews in North America and Western Europe one finds writers moonlighting as critics, artists switch-hitting as the same, or philosophers unwinding, but almost no one tagged as "art critic" pure and simple. Odder still is that art critics are fairly scarce in prominent art magazines like *Artforum*. What has happened to this figure that, only a generation or two ago, strode through the cultural landscape with the force of a Clement Greenberg or a Harold Rosenberg?

Challenging Art: Artforum 1962–74 provides a few clues to this strange disappearance.[1] Stitched together by Amy Newman, a former managing editor of *ArtNews*, out of seven years of interviews with the principal players at *Artforum*, *Challenging Art* tells the story of the magazine from its inauspicious beginnings in San Francisco in 1962, through its glory days as the influential review of contem-

porary art in the late 1960s, to its editorial meltdown in New York in 1974. Some of the participants are now well-known, such as the art historians Michael Fried and Rosalind Krauss; some are semi-forgotten, such as the founding editor, Philip Leider; and some deserve wider appreciation, such as Annette Michelson, the doyenne of cinema studies. The result is a retrospective document, an oral history of art criticism in the United States in the 1960s and 1970s. For almost all the witnesses believe that art criticism became a "serious discipline" in the US only at this time, and primarily through the medium of *Artforum*.

"*Challenging Art* takes the form of a 'conversation'," Newman tells us, "although each speaker was interviewed individually." One sees why immediately: some wounds are not healed, and we watch others reopen as the participants reminisce (one needs a scorecard to track all the old account-settling and new point-making). Depressingly, old divisions between formalist and social–historical approaches, theoretical and belle-lettristic voices, and apolitical and engaged positions, are reaffirmed. Yet all this festering reminds us that good criticism is often born of great resentment, and that philosophical ruptures sometimes stem from petty disputes. For example, the book reproduces the notorious 1974 advertisement showing the artist Lynda Benglis, naked, tanned and oiled, holding a massive dildo to her crotch – and cracking apart an already tense editorial board (associate editors Krauss and Michelson left at this time, later to found *October* magazine). Opinions still swirl around this flamboyant gesture: was it a feminist assertion of power, or the opposite? A mocking of the art market, or an act of self-promotion taken to a soft-porn extreme that let loose the Jeff Koonses and Damien Hirsts of the world? Many episodes of this era are similarly ambiguous.

Artforum is identified with the Big Apple, but it began on the Left Coast, humbly enough, in a San Francisco gallery where Leider,

a lit-crit type from New York, worked as an assistant. Along with his early collaborators James Monte and John Coplans, Leider outgrew the Beat-dominated Bay Area (where commerce in art was viewed as corruption), and moved the magazine to Los Angeles in 1965. With artists like Ed Keinholz and curators like Walter Hopps, the LA scene was livelier: Andy Warhol first showed his Campbell soup cans at the Ferus Gallery in 1962, and Marcel Duchamp had an influential retrospective at the Pasadena Art Museum in 1963. A couple of years here prepared Leider for the move to New York in 1967, where the magazine was lured by cutting-edge artists and critics, not to mention bottom-line gallery advertising. This was a very different setting once again.

New York was a big step closer to Europe, but one wouldn't know it from *Artforum*. In the wake of Abstract Expressionism, later dubbed "The Triumph of American Painting," ambitious artists and critics in the US were chauvinistic about homebred modernism, and they liked to imagine Europe as played out. "Europe was in total shreds and decadent and used up," Barbara Rose gushes here, "and we had people like Barnett Newman and Pollock and really great artists." This is the artistic version of "Manifest Destiny" or "The American Century": after the European deluge comes Abstract Expressionism, and after Ab Ex comes us.[2] However, several witnesses intimate another factor in this national hubris: many of these young radicals were children of immigrants and/or Jews for whom the US remained an open New World and Europe an ambiguous Old World – to be either forgotten or overcome, in any case somehow superseded. Other conditions set up this new generation as well. It was "maybe the very last," Leider suggests, "to get one of those great educations in the public school systems" of big cities like New York and Washington. It also benefited from the postwar boom in American universities, with new MA and MFA programs

that gave this group – whether champions of abstract painting or critics of this modernist form – a historical consciousness and philosophical sophistication without precedent in the US. Some of this number rode in from the academic world to the art world, which was also newly expanded in the 1960s by market interest and media attention; and later on some rode back to it as well.

Ambivalence toward a "used up" Europe was already structural to the writing of Clement Greenberg, the *éminence grise* of *Artforum* critics such as Leider, Fried, Rose, and Krauss. In his 1961 summa, "Modernist Painting," Greenberg details all that American art had "criticized" and "abandoned," only to conclude: "Nothing could be further from the authentic art of our time than the idea of a rupture of continuity."[3] In *Challenging Art* both allies and enemies agree that Greenberg had redeemed art criticism from its intellectual disrepute in the 1940s and 1950s (it was not central to "the New York intellectual" formed around *Partisan Review*, say, which was primarily literary in focus), and that he had done so through the sheer cogency of his formalist briefs for Pollock, Newman, and others – how this painting worked, and why it was necessary for its time. Yet Greenberg was not the only star in the art-critical sky; in fact it was only after *Art and Culture*, his collection of essays, appeared in 1962 that his thought worked its way deep into this generation. (This was the same year *Artforum* was founded, and about the time that his own writing hardened into fundamentalist pronouncements.) Several witnesses also attest to the formative influence of the contextual teachings of Meyer Schapiro, the art historian at Columbia University whose writings ranged from Romanesque architecture to Rothko abstractions. The triangulation of father-figures was completed by Harold Rosenberg, later art critic at *The New Yorker* and professor at the University of Chicago, who moved methodologically between the other two patriarchs, and who

served as a role model for an additional subset of *Artforum* writers, Max Kozloff chief among them. Yet for the critics who most marked *Artforum* – first Fried and Rose, then Michelson and Krauss – Rosenberg was all "fustian writing," an aspersion that they also cast at poet-critics like Frank O'Hara and John Ashbery (and later Peter Schjeldahl and Carter Ratcliff) associated with *ArtNews* under its editor Tom Hess. This was not art criticism as a "serious discipline."

Of course such oppositions as formalist versus social–historical methods, and objective versus belle-lettristic styles, long preceded *Artforum*, but for this generation they were compounded most volatilely in its milieu. It was not an even match. Whereas the poet-critics had only an attenuated connection to the belle-lettristic reviews of the French Salons to stand on, the formalist followers of Greenberg could draw on the immediate prestige not only of New Criticism in literary studies but also of German art history as established in the American university by such prewar émigrés as Erwin Panofsky. The formalist camp felt that it had a near-scientific view of art history to support its semi-subjective judgments of aesthetic quality (here Fried aligns Greenberg with T. S. Eliot, and Leider relates his *Artforum* to *Scrutiny* under F. R. Leavis). No wonder such criticism appeared so powerful and, to its opponents, so presumptuous. "They were successfully putting over the impression," Ratcliff complains, "that they were writing the final draft of history as it happened." What Fried calls "surfing the dialectic" Kozloff condemns as "hindsighting the contemporary": "immediately breaking developments by leaping ahead to figure out where the artists should go." The implicit tense of some *Artforum* criticism was indeed the future anterior. With Greenberg this predictive, even prescriptive temporality became almost systematic: rather than test present art against past masters, he came to marshal past art in support of present pretenders.

As befits an *éminence grise*, Greenberg was not an active presence in *Artforum*. He didn't need to be, as Leider was in thrall to his lieutenants, especially Fried ("for many years I felt that if nothing else was remembered in the magazine what Michael wrote would be"); and until Leider fell under the influence of anti-formalist artists like Smithson the "Greenbergers" dominated the magazine intellectually. So what were the attractions of the Greenbergian world-view? As one might expect, the portrait of Greenberg that emerges here is complex and paradoxical. His criticism won over the young Fried and Krauss because it was "practical" and "verifiable"; Rose underscores its "clarity and culture" as well. More heady was his sense of historical purchase, his ability "to make his judgements in the name of 'art history'" (Rose); this promise of place or will to power was a primary seduction. Yet here the contradictions or duplicities came to the fore as well, for when Greenberg was challenged on questions of history he would defend his judgment as a matter of taste, and when contested on taste he would appeal to history. (As far back as "Towards a Newer Laocoön" [1940] he writes, "I find that I have offered no other explanation for the present superiority of abstract art than its historical justification.")[4] This move made his system very hard to dispute, but it also revealed Greenberg to be "apodictic" (Fried), "capricious" (Kozloff), more "papal" than critical (Robert Rosenblum); or, as Rose puts it succinctly, "Clem gave you the road map *and* the driving test." "A psychologically potent person" (Fried), Greenberg possessed enormous "rhetorical advantages" over "historical assumptions, over the market, over mind" (Kozloff). Yet these advantages were eroded as his system became less "an analytical tool" than "a way of picking the winners" (Rose). This picking was bad enough; worse is that by the mid-1960s Greenberg was betting on the wrong ponies (on this score the usual horse to flog is the

ARTFORUM

Morris Louis, *Aleph*, 1959,
acrylic on canvas, 93 × 104″.

painter Jules Olitski, but many others were equally lame). What
Fried championed as "the dialectic of modernism" critics like Leo
Steinberg came to question as the involuted logic of design innova-
tion à la Detroit automobile styling.[5]

Subject to pressures within and without, the Greenberg bloc
could not last. As "a clutch of *Artforum* writers wanted to update
and yet outflank him" (Kozloff), there was both Oedipal tension
with Greenberg and sibling rivalry among the Greenbergers. "The
generation that you can say Frank Stella started" (Fried) soon
devolved into two camps. On the one side were Greenbergers like
Fried, Rose, and Krauss, who, at least for a time, supported the
Color Field painters that stemmed from Pollock (Morris Louis,
Kenneth Noland, Olitski). On the other side were artist-critics like
Donald Judd, Dan Flavin, and Carl Andre, who took the Greenberg-
ian call for an objective art so literally as to transgress his medium-
specific proscription in the creation of objects that were neither
painting nor sculpture at all. This division came to a head over

ARTFORUM

Frank Stella, *Darabjerd I*, 1967,
fluorescent acrylic on canvas,
10 x 15′.

Minimalist art, specifically over the work of Stella, which each camp
claimed as its own; from there the split worked its way back into
the Greenberg camp as well. Greenberg drew his canonical line
before Stella, Fried after Stella but before Minimalist "objecthood,"
while Rose wanted to include both, for like Stella (her husband at
the time) she recognized the Minimalist reading of his painting as a
rightful one. What ensued was a series of dramatic ruptures whereby
the Greenbergers broke away one by one.

Rose bolted first; as early as 1966 she questioned an account of
modernism that could exclude Dada, Surrealism, and, in the pres-
ent, Robert Rauschenberg, Jasper Johns, and all of Pop art. In
different ways Krauss and Leider were won over by artists who
emerged from Minimalism, in part through a divergent reading of
Pollock as performative more than pictorial, about the procedure
more than the painting: Krauss became intrigued by the investi-
gations into material process and anti-formal composition under-
taken by Robert Morris and Richard Serra; Leider by the one-man

Larry Bell, *Memories of Mike*, 1966–67, metal and glass, 24″ square.

paradigm shift that was Robert Smithson. "These people are not the threat," Leider recalls thinking; "they're the logical continuation. People like Serra and Smithson . . . are people who come out of *us*." Fried could abide none of this; he parted not only with Greenberg over Stella but with fellow Greenbergers over these new attachments – all bad objects for him as they both misconstrued the historical logic of modernist painting and flew in the face of its transcendental effect of "presentness." Gradually Fried withdrew from the contemporary scene in order to pursue a geneaology of modernist art and criticism from Diderot and David through Baudelaire and Manet (his dissertation on Manet was published as an entire issue of *Artforum* in 1969). Brilliant though it is, this historical project can also be read as a work of mourning for an object that became more and more lost in his own present.

Wounded at this point, Greenberg became more hunted than hunter. Only nascent at the start of the decade, "the germ of the anti-Greenberg revolt" (Rose) was airborne and epidemic by its

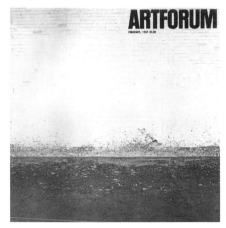

Richard Serra, *Untitled*, 1968, lead.

end. Artists looked to other precedents, especially in the circle of John Cage, Merce Cunningham, Rauschenberg, and Johns, while critics sketched out "other criteria," as proposed most cogently by Steinberg. Also at this moment Michelson became a crucial guide, with her commitments not only to the Cage–Cunningham circle, Judson Church dance and performance (e.g., Yvonne Rainer, Trisha Brown), structural film and photography (e.g., Michael Snow, Hollis Frampton), but also to critical models from André Bazin to Roland Barthes discovered during her long stay in Paris in the 1950s and early 1960s. Michelson was an early exponent of "French theory" in the US (primarily structuralist and poststructuralist), and Krauss, who soon sided with her, an early elaborator of its art-critical implications. In sum, there was an opening to other practices in the States and abroad, and in this opening emerged a fast and furious dialogue among conceptual, process, body, performance, video, site-specific, earthwork, and installation artists.

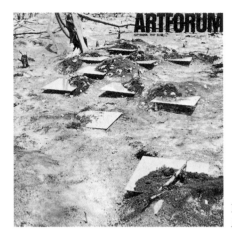

Robert Smithson, *First Mirror Displacement*, 1969, Yucatan.

For a time this contest of aesthetic models – in shorthand a collision between late-modernist painting and neo-avant-garde alternatives – made *Artforum* very dynamic. It also made it extremely unstable. "I knew that the days of such a venture were limited by the volatile nature of the personalities involved," Leider wrote Fried in March 1966, "and that I could expect a year, perhaps two, during which I could hold the mixture in some kind of suspension, after which it would explode into its incompatible, irrevocably hostile elements." This is theatrically stated – Leider did not depart the magazine until 1971 – but it is not substantially wrong. The high point of dialectical complexity in *Artforum* followed soon after this letter, just before the move to New York, in the Summer 1967 issue on "American Sculpture." It juxtaposed Fried contra Minimalism in "Art and Objecthood," Morris pro Minimalism in "Notes on Sculpture, Part 3," Smithson on earthworks in "Towards the Development of an Air Terminal Site," and Sol LeWitt on Conceptualism in "Paragraphs on Conceptual Art."

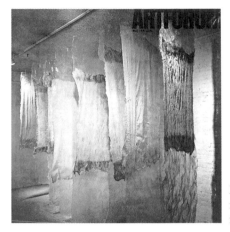

Eva Hesse, *Contingent*, 1969,
rubberized cheesecloth with
fiberglass, 11′ long.

An extraordinary instance of interlocked debate, this one issue is
worth a whole run of many other art magazines.

Yet a problem is registered in this very appraisal: a tendency to
romanticize this moment in general and this magazine in particular
(*Challenging Art* is only one instance of a major reinvestment in art
and criticism of the 1960s today). Again Leider plays the lead here;
and though his voice is paradoxical, by turns self-deprecatory and
hubristic, loyal and dismissive, his conclusion is essentially *après
moi la merde*. Yet *Artforum* did go on after Leider left it abruptly,
once its kitchen of criticism and commerce got too hot for him.
And he left it in dire straits, for its next editor, John Coplans, took
over a magazine that was effectively bankrupt and ideologically
divided. For witnesses faithful to Leider, Coplans is the villain of the
piece. Fried constructs a noble departure for Leider: "He did what
he felt to be true and when he didn't believe it any more he got up
and left." Leider should have stuck with this story; his is far less
gracious in its guilt-ridden omniscience:

I just knew what the long-range consequences were going to be. First of all, the degeneration of the magazine, the loss of direction. I didn't see how rapidly or how absurdly [Coplans] would politicize it, but I should have. I knew that he wouldn't know good writing when he saw it ... I knew that he was incapable of holding a staff together. And I knew that *my* staff would never live with him. And I think I also knew that with this was going to begin a trend that was going to end up with today's art, that's all. And that's what is, I think, so unforgivable: that I think I knew that then.

Coplans has his defenders here: Kozloff opines that "the magazine grew thicker and more various" under his editorship. Coplans has his say too, and he admits to manipulating "cabals of hatred" (primarily Krauss and Michelson versus Kozloff and Lawrence Alloway, fellow anti-Greenbergian gadflies with whom he was more sympathetic) and paying for it: "I had unleashed my own furies, so to speak." But Coplans is outnumbered and drowned out in this book.

<div align="center">*</div>

So what sort of narrative does *Challenging Art* tell? For its editor Newman it is an epic: the rise of art criticism as a serious discipline in the US. Yet for participants like Fried it is semi-tragic: the decline of the modernist critic ("I wasn't aware that I would be the last of my kind," he remarks at one point). How can we reconcile these two views? Perhaps the stories are intertwined, and *Artforum* marks neither a beginning nor an end but a changing of the guard. On the one hand, there is a decline in the old model of the critic based on the New York intellectual, liberal in culture and politics, with one foot in the Old Left and "one foot in the loft" (as artist-author Brian O'Doherty puts it here). On the other hand, there is a rise in

a new sort of critic bound up with a different kind of avant-garde, one involved in critical theory and inspired by feminist politics, more subversive in the short run but perhaps more academic in the long term. In this light the *Artforum* of this period appears not as a lost paradise but as another way-station – in the passage between the worlds of *Partisan Review* and *October*, say, or *Scrutiny* and *Screen*.

For many witnesses, however, this moment of *Artforum* was more terminal than transitional. Here the tone becomes tragic–comic, as several critics rehearse how they drew aesthetic lines in the sand, only to see them washed away by loathsome developments: Fried by theater-corrupted art, Leider by knee-jerk politics, Rose by the money-mad art market, and so on. To what degree were the repudiations that followed historical acts, and to what degree histrionic? That is, were these moments when "the dialectic of modernism" crashed on the beach, or when each critic failed to surf it further? Either way some witnesses swear to the high stakes involved. Krauss: "What was at stake was the fate of cultural experience." Leider: "If you didn't hold this line then you were going to be in some part responsible for the collapse of the culture." Fried: "I thought that nothing less than the future of Western civilization was at stake in 'Art and Objecthood' and the other essays of 1966–67. I'm being ironic, but only up to a point. That was thrilling, it remains thrilling to me, I wouldn't have missed it for anything." These statements might make for easy targets now (if Western civilization depended on a spray painting by Olitski, then it truly was in trouble), but the thrill was real, as was the freighting of art and criticism. How did they get so fraught?

Several factors overdetermined the situation. The test posed by this criticism was that art should "compel conviction" (Fried),

and this kind of insistence suggests that aesthetics was asked to carry too much of the weight of ethics and politics. That is, this milieu of artists and critics practiced a partial subsuming or sublimating of ethical and political questions into artistic and critical debate. "All issues ultimately were moral issues," Rose recalls; and later, in a great non sequitur, she states: "Since you could not see any developments of the Marxist agenda in the society, and if you continued to believe in social justice or in a dialectical way of thinking, then you had to do it someplace else, and that was, of course, *Artforum*." Fried works to justify both kinds of displacement – ethical and political – early on in a 1965 text for an exhibition that he curated at Harvard, "Three American Painters: Morris Louis, Jules Olitski, Frank Stella." First as regards the political:

[The dialectic of modernism] would amount to nothing less than the establishment of a perpetual revolution – perpetual because bent on unceasing radical criticism of itself. It is no wonder such an ideal has not been realized in the realm of politics; but it seems to be that the development of modernist painting over the past century has led to a situation that may be described in these terms.

Then as regards the ethical:

While modernist painting has increasingly divorced itself from the concerns of the society in which it precariously flourishes, the actual dialectic by which it is made has taken on more and more of the denseness, structure and complexity of moral experience – that is, of life itself, but life lived as few are inclined to live it: in a state of continuous intellectual and moral alertness.[6]

No wonder that Krauss calls "the atmosphere exceedingly thin." No wonder, too, that this sublimation of the ethical and the political was soon reversed by developments in the New Left, a pumped-up market, and feminism.

Yet these factors do not account for the sheer fervor of the avowals and disavowals of this criticism (Fried hunted Minimalism with the intensity of a critical Ahab). Apart from personal antagonism and youthful arrogance, the very grandiloquence of the criticism sometimes betrays a certain desperation. Krauss designates hyperbole as "the very form of speech" of Leider, Fried, and others, and Fried admits to "the tremendous stress on the writing," which he interprets as an attempt "to get the intensity of the response into the right register," to match the power of the art rhetorically. But at the time some cynics argued the near opposite: Tom Wolfe notoriously trashed all late-modernist art as a critical scam, a "painted word" contrived in "Cultureberg" (his anti-Semitic slam against Greenberg, Rosenberg, and Steinberg).[7] Yet far from a scam, the criticism was a support; listen to the honest uncertainty of Leider here: "The verbal part, the theoretical part, sustained me through my doubts. Every time I began to doubt the way things looked, the value, the quality, the plain quality of the work as it looked to me, I was able to fall back on this *structure* of thought."

Late-modernist criticism struggled to make fine distinctions on which a great deal was thought to ride – the difference, say, between the modernist "art" of a shaped painting by Stella or Noland and the mundane "objecthood" of a Minimalist box by Judd or Larry Bell. In this way such criticism tended to turn tentative distinctions into secure ontologies, and it did so, consciously or not, to shore up an aesthetic field that was pressured and fragile. What was involved here was less "hyperbole" than "hypostatization," an awkward term for a common move in art criticism: the inflating of

attributes into entities. One can hear the adjectives become nouns, the descriptions become essences, as Greenberg writes of the "flatness" of late-modernist painting, Krauss of its "frontality," or Fried of its "opticality." Why this hypostatization of terms? Again, consciously or not, these terms were deployed as bulwarks for an aesthetic field that appeared broached from without and eroded from within. The external enemy was "kitsch," "theatricality," everyday life in commodity culture; the internal enemy was the expanded arena of art prepared by Minimalism. That is why Minimalism was so dangerous to Greenberg, Fried, and others: they rightly understood that it might open art beyond the proper mediums of painting and sculpture, that it might lead art into an arbitrary realm beyond criteria.

The problem of the arbitrary was felt by many artists and critics in the 1960s and 1970s. Whereas the *Artforum* core resisted it through a hyper-refinement of institutional forms like modernist painting, others undertook a "search for the motivated" (as Morris called it) in the sheer materiality of new substances and processes, or in the sheer actuality of the body of the artist and the site of the work (as Serra explored it).[8] Yet the irony (or pathos) of this other project was this: even as it sought to remotivate and to reground art, to render its making and meaning more transparent to its audience, the effect was often the opposite – to make art appear more arbitrary and rarefied, to opacify it further. Also ironic was that the demonstration on the Greenbergian side was not so different in the end either. For what was disclosed in the hyper-refinement of modernist painting was not the final essence of painting (as Greenberg seemed to claim), or even its necessary conventionality (which is the correction that Fried offered), so much as the fragility of its conventions as the basis of shared meanings – shared, that is, with a public broader than assiduous

readers of *Artforum*. For Fried, as for his philosophical interlocutor Stanley Cavell, this dicey situation *is* the modernist condition, and the purpose of the modernist work is to test the limit of its meanings and the understanding of its viewers over and over again. This is why, at a time when artistic conventions became less familiar, let alone shared, consensual or contractual, "compelling conviction" became so urgent. But this is also why it became so difficult (and, in any case, to turn a problem into a project is not to solve it). "It was an enterprise," Fried writes in a 1971 essay on the late-modernist painting of Morris Louis, "which unless inspired by moral and intellectual passion was doomed to triviality, and unless informed by uncommon powers of moral and intellectual discrimination was doomed to failure."[9] Thomas Crow once glossed this statement succinctly: "Modernist criticism brought into the 1960s a surplus of moral commitment that was the relic of an earlier dream of art as the focus on an ideal public sphere."[10]

Where are we now? If the decline of the modernist critic of the *Artforum* ilk was also the rise of the critic-theorist of the *October* sort, this figure has begun to subside in turn. On the cultural front he or she has multiplied across many different disciplines and postmodernist debates. On the professional front, if the *Artforum* critic had one foot in the loft, the *October* theorist has one foot in the academy, and now he or she is often born and raised there. But this self-removal to the academy is only part of the story. On the institutional front both kinds of critic were also displaced in the 1980s and 1990s by a new nexus of dealers, collectors, and curators for whom critical evaluation, let alone theoretical analysis, was of little use. They were usually deemed an obstruction, and many managers of art now actively shun them, as do many artists, sadly enough. In this void we witness the partial revenge of the poet-critic who waxes on about the necessary return of Beauty and Spirituality

as the essential subjects of Art, with Shock and Sensation held over as fun standbys or sideshows to feed the mass media. Here, I suppose, is where I draw my line, but it is already washed away.

So we are still in the aftermath of the crisis of the arbitrary, in an expanded field of art that sometimes seems vital and sometimes entropic, in which the breakthroughs of the 1960s appear both as departures to reclaim and as breakdowns to overcome. And here the· last words might be the first words of Adorno in *Aesthetic Theory*, written in the midst of the period surveyed by *Challenging Art*:

> It is self-evident that nothing concerning art is self-evident anymore, not its inner life, not its relation to the word, not even its right to exist. The forfeiture of what could be done spontaneously or unproblematically has not been compensated for by the open infinitude of new possibilities that reflection confronts. In many ways, expansion appears as contraction . . .[11]

THIS FUNERAL IS FOR THE WRONG CORPSE

"It is self-evident that nothing concerning art is self-evident anymore," Adorno wrote in 1969, "not its inner life, not its relation to the word, not even its right to exist ... In many ways, expansion appears as contraction." Today, thirty-plus years later, might this statement circle back so as to include its own implicit assumption about "the end of art"? In other words, might "the end of art" be one more thing about art that is not "self-evident anymore"?

In the trivial sense, of course, this end never came, but then "the end of art" never meant a literal stop to paintings, sculptures, films, novels, and all the rest; what was at issue was the formal innovation and historical significance of these mediums. For many believers art had long served as the essential index to its culture, to its age, or (in its strongest Hegelian formulation) to the realiz-

ation of Spirit in History. Yet for some time now art has not possessed this symbolic weightiness: today it seems divested not only of its role as a signpost to history but also of much regard for historicity – that is to say, for any necessary working-through of its own historically given problems. One might go further: contemporary art no longer seems "contemporary," in the sense that it no longer has a privileged purchase on the present, or even "symptomatic," at least no more so than many other cultural phenomena. If the first principle of art history, as Heinrich Wölfflin once put it, is that "not all things are possible at all times," this premise appears challenged in the present, for good and for bad, with the result that, for some commentators, art history is as kaput as art is.[1]

Adorno offered his version of "the end of art" at a time when such proclamations – concerning the end of ideology and philosophy as well – came fast and furious. In 1965, for example, the Minimalist artist Donald Judd averred that "linear history has unraveled somewhat," and soon thereafter the Conceptual artist Joseph Kosuth announced that modernist painting and sculpture were finished.[2] But, Kosuth added in a "dialectical" fillip that made all the difference, these specific mediums were now sublated in the general idea of Art, and this Art with a capital A was henceforth the proper object-medium of advanced artists. Presented as the end of Hegelian art history (modernist and otherwise), this position was instead its epitome – of art transcended in philosophy, in art-as-philosophy. The philosopher Arthur Danto had a similar epiphany, which he also dated to the mid-1960s with his first encounter with the *Brillo Box* of Warhol, and in a series of books begun in the 1980s he has made this vision of transcendence his own.[3] According to this argument, Warhol perfected the Duchampian question of "what is art?" and so, intentionally or not, brought art into philosophical

self-awareness. But by the same token art no longer had any philosophical work to do: its essential rationale fell away, and henceforth it could do *whatever* – to be evaluated, if at all, by the philosopher-critic according to its degree of philosophical interest (we see, then, who is privileged in this account). This "end of art" is presented as benignly liberal – art is pluralistic, its practice pragmatic, and its field multicultural – but this position is also not-so-benignly neo-liberal, in the sense that its relativism is what the rule of the market requires.

Two other versions of the end, further to the left, also emerged in the 1980s. The first, poststructuralist account was triumphal in tone: art is no more, "representation" is all; the history and theory of art are subsumed by the history and theory of representations, to be understood in terms of textual production and psychological reception. (Visual studies has taken over this version, with revisions that ground representation in social practices.) The second, Marxist account was more desperate: here art is not subsumed by the theoretical category of representation but overwhelmed by the practical dominance of "the image," the primary form of the commodity in a spectacle economy, from which art can no longer pretend to be distinct.[4] I don't disagree with certain aspects of either argument, but they concede too much too quickly, and I want to recover some of what they surrender. I also don't deny that our condition is largely one of aftermath – that we live in the wake not only of modernist painting and sculpture but of post-modernist deconstructions of these forms as well, in the wake not only of the prewar avant-gardes but of the postwar neo-avant-gardes as well. But there are other responses to this condition than triumphalism or desperation, or indeed melancholy (at the very least we need not pathologize it further). Here I want to ask another kind of question: what comes after these ends, or perhaps

(if they did not quite occur) in lieu of them? As the Mekons sang of the death of socialism after 1989, might these funerals be for the wrong corpse?

<div align="center">*</div>

Let me review this condition of aftermath briefly, and begin with the wake of modernism and postmodernism. In previous chapters I alluded to a "dialectic of modernism" that formalist critics like Clement Greenberg and Michael Fried extracted from advanced painting from Manet to Frank Stella. This "dialectic" was pledged to formal unity and historical continuity, and, like the history of premodernist art according to Wölfflin, it was governed by a double dynamic of a continuous "palling" in perception and problem-solving in form; at least in this account (which ignored market considerations), this is what drove the ceaseless search for stylistic variations in modernist painting. As we have seen, this Wölfflinian modernism ran into the sand in the 1960s, but it was kept in place as a foil for practices that emerged to contest it, such as Minimal and Conceptual art, Process and Body art. These practices critiqued this modernism, but in so doing they also continued it, at least as a reference. In its very decay modernism thus radiated an afterlife that we came to call postmodernism (here the term pertains only to critical art of this sort).

This doubling of modernism and postmodernism can be gleaned from a glance at a signal mapping of site-specific art. In "Sculpture in the Expanded Field" (1979) Rosalind Krauss presented a structuralist account of such art: neither modernist painting nor modernist sculpture, it emerged as the negative of these categories, and soon opened onto other categories, such as "architecture" and "landscape" and "not-architecture" and "not-landscape."[5] These terms provided the points of reference by which Krauss plotted

the practices of "marked sites" (e.g., Robert Smithson), "site con-
structions" (e.g., Mary Miss), and "axiomatic structures" (e.g., Sol
LeWitt). Implicit in this account is that postmodernist art was
initially "propped" on modernist categories, with all the ambiguity
of (in)dependence implied by the word, but that it soon "troped"
these categories, in the sense that it treated them as so many
completed practices or given terms to be manipulated as such. This
map also now registers certain changes since that time: over the last
three decades the "expanded field" has slowly imploded, as terms
once held in productive contradiction have gradually collapsed into
compounds without much tension, as in the many combinations of
the pictorial and the sculptural, or of art and architecture, in
installation art today – art that, for the most part, fits well enough
into the pervasive design-and-display culture critiqued elsewhere in
this book. This is only one indication of how postmodernist art,
which emerged as a troping of modernist categories, is now trumped
in turn.

As a result the model of a formalist modernism challenged by
an expansive postmodernism no longer drives or describes signifi-
cant developments in art or criticism. And the same must be said
of its historical double, the model of a prewar avant-garde recov-
ered by a postwar neo-avant-garde (e.g., of Dadaist devices or
Constructivist structures recovered in Fluxus or Minimalism). Here
again the debate runs back to the mid-1960s when, for radical
critics like Guy Debord, the avant-garde was already bankrupt.
"Dadaism sought to abolish art without realizing it," Debord wrote
in *The Society of the Spectacle* (1967), "and Surrealism sought to
realize it without abolishing it."[6] The failures were reciprocal for
Debord, and any attempt to revive such attempts, as in the various
neo-Dadas of the 1950s and 1960s, were farcical: far better to have
done with the entire project. This opinion, which evokes the

famous charge of Marx in *The Eighteenth Brumaire of Louis Bonaparte* (1852) that history occurs twice, the first time as tragedy, the second time as farce, was upheld by Peter Bürger in his influential *Theory of the Avant-Garde* (1974). In fact Bürger extended the critique: the repetition of the historical avant-garde in the neo-avant-garde was not only farcical; it also reversed the original project to reconnect the institution of autonomous art with the practice of everyday life – recouped it for the very institution that was to be challenged in the first place.

Benjamin Buchloh has exposed the historical lacunae in this argument, and I have posed another model of neo-avant-garde repetition that is not merely recuperative.[7] More importantly, the 1970s and 1980s saw critical elaborations of the neo-avant-garde, and the 1990s and 2000s have witnessed various attempts to recover unfinished projects of the 1960s as well – that is, to set up a further "neo" relation of recovery vis-à-vis Conceptual, Process, and Body art in particular. Yet this work has not yet demonstrated whether critiques as singular as Conceptual, Process, and Body art can be transformed into a tradition (or tradition-substitute) coherent enough to support contemporary practice. As a result the recursive strategy of the "neo" appears as attenuated today as the oppositional logic of the "post" is tired: neither suffices as a strong paradigm for artistic or critical practice, and no other model stands in their stead. For many this is a good thing: it permits artistic diversity; "weak" theory is better than strong; and so on. But, as I have argued elsewhere in this book, our paradigm-of-no-paradigm can also abet a flat indifference, a stagnant incommensurability, a new Alexandrianism, and this posthistorical default of contemporary art is no improvement on the old historicist determinism of modernist art. All of us (artists, critics, curators, historians, viewers) need some narrative to focus our present practices – situated stories, not *grands*

récits. Without this guide we may remain swamped in the double wake of post/modernism and the neo/avant-garde. Rather than deny this aftermath, then, why not admit it and ask "what now, what else?"

Let me recall another riddle posed by Adorno in the mid-1960s, which is still an unsettled origin of so much art today. If his worry about the arbitrariness of art begins his *Aesthetic Theory*, his riddle about the relevance of philosophy opens his *Negative Dialectics* (1966): "Philosophy, which once seemed absolute, lives on because the moment to realize it was missed."[8] Here Adorno responds to another famous charge of Marx, this one in the "Theses on Feuerbach" (1845), that philosophers have only interpreted the world when the point is to change it.[9] In a sense, just as philosophy missed its moment of realization, so the avant-garde missed its moment; and I wonder if this parallel guided Adorno and, further, if we might substitute "art" where he writes "philosophy." In this case, might art be granted the ambiguous stay of sentence that Adorno grants philosophy – the possibility of "living on"? (Again, this is the possibility that critics like Debord and Bürger foreclose in the same moment.) If so, what might this "living on" be in the present? Not the overt repetition of avant-garde devices that characterized much neo-avant-garde art of the 1950s and 1960s (e.g., monochrome painting, collage, readymade objects), and perhaps not the attenuated working-through of such strategies that characterized much neo-avant-garde art of the 1970s and 1980s either (e.g., institution-critiques that are sometimes difficult to decipher even for initiates). Maybe this living-on is not a repeating so much as a making-new or simply a making-do with what-comes-after, a beginning again and/or elsewhere.

<div align="center">*</div>

At this point I can only sketch a few versions of this living-on, which I will call "traumatic," "spectral," "nonsynchronous," and "incongruent." As these categories tend to cross, this taxonomy is artificial, and my disparate examples (which include fiction and film) do not pretend to be comprehensive; nonetheless, they may begin to evoke this condition of coming-after. Even as the practices I have in mind often treat given genres or mediums as somehow completed, they do not pastiche them in a posthistorical manner. On the contrary, they are committed to formal transformations – as long as these transformations also speak to extrinsic concerns. In this way these practices point to a semi-autonomy of genre or medium, but in a reflexive way that opens onto social issues ("a closed world that is open to the world" is how one contemporary artist puts it); in so doing they often belie these very oppositions of intrinsic and extrinsic, inside and outside.[10] Through formal transformation that is also social engagement, then, such work helps to restore a mnemonic dimension to contemporary art, and to resist the presentist totality of design in culture today.

My first version of living-on involves *traumatic* experience. Of course, for the avant-garde to be recovered, it first had to be lost, and this breach, which began with its suppression by Nazis and Stalinists in the 1930s, was deepened with the trauma of war and Holocaust in the 1940s. More than a historical divide in art, this breach induced a cultural blockage, "a failure to mourn," that long persisted. In our own time, however, this failure (or refusal) of memory has promoted a compensatory imperative to remember in the form of new museums and trauma studies of all sorts – an imperative that sometimes seems more automatic than mnemonic. In both popular culture and academic discourse "trauma" has come to float free as a general signifier of the structuring not only of subjectivity but of history as such. Today some of the most provoc-

ative novelists and filmmakers also conceive experience in this paradoxical modality – of experience that is *not* experienced, at least not punctually, that comes too early or too late to be registered consciously, that can only be repeated compulsively or pieced together after the fact. Often for these novelists (I think of Paul Auster, Russell Banks, Dennis Cooper, Don DeLillo, Steve Erickson, Denis Johnson, Ian McEwan, Toni Morrison, Tim O'Brien, and W. G. Sebald among others, but such filmmakers as Atom Egoyan should also be cited) narrative runs in reverse or moves very erratically, and the peripeteia is an event that happened long ago or not at all, in keeping with the ambiguous nature of trauma as real or fantasmatic.

As one might expect, contemporary art that treats "the German Question" is often concerned with the traumatic, whether in terms of the ruins of the Nazi past (as evoked by Hans Haacke in his extraordinary *Germania* installation in the 1993 Venice Biennale, where he broke apart the marble floor of the Nazi-era pavilion) or the unburied persistence of this past in reconstructed Germany (as evoked by Gerhard Richter in his equally extraordinary *October 18, 1977*, a 1988 suite of paintings concerning the Baader–Meinhof gang). However, my example here is a 1989 installation by Robert Gober that evokes the trauma of American racism, and so exceeds the limits of the last century. In one room Gober hung wallpaper of penises and vaginas, anuses and navels, sketched in white line on black ground and punctuated with chest-high drains, and in another room wallpaper of schematic drawings of two men in light blue on pale yellow, one white and asleep (from a Bloomingdale's beefcake advertisement), the other black and lynched (from a 1920s Texas cartoon). If the first background presented sexual difference as the overlooked pattern of our everyday lives, the second suggested that racial antagonism is another occluded structure of our daily grinds.

Each room was further split into two registers: in the center of the first was a bag of doughnuts on a pedestal; in the center of the second a wedding gown attended by bags of "Fine Fare Cat Litter" set along the wall (all objects and images looked found but were handmade). Thus, from space to space and from images to objects, Gober put a series of oppositions in play: male and female, bachelors and bride, white and black, immaculate gown and stale food, purity and pollution, dream and reality, and, above all, sexual difference and racial difference.

Rather than map these oppositions onto one another, however, Gober intertwined the terms in an ensemble that evoked the intricacies of fear, desire, and pain deep in our political imaginary of race and sexuality. The installation prompted the viewer to tease out this old American knot in the form of a broken allegory: What is the relationship between the two men? Does the black man haunt the white man? Does the white man dream the black man? If so, does the white man conjure the black man in hatred, guilt, or desire? Is the woman implied by the wedding gown the object of their struggle? If so, is she the pretext of their violence, the relay of their longing, or both? What is the role of heterosexual fantasy in racial politics? Of racial fantasy in heterosexual politics? And how does homosexuality or homosociality come into play? Finally, how does one *disar*ticulate all these terms – clarify them in order to question them? Traumatically mute, the installation intimated that our traumas of identity and difference are collective as well as individual, and that our racist–homophobic past lives on, nightmarishly, in the present.

The Gober installation developed certain elements of Duchamp, such as the bride from *The Bride Stripped Bare by Her Bachelors, Even* (1915–23), his large glass divided into two registers, and the diorama of sexual difference from *Etant donnés* (1946–66), his mannequin splayed in a landscape on view at the Philadelphia

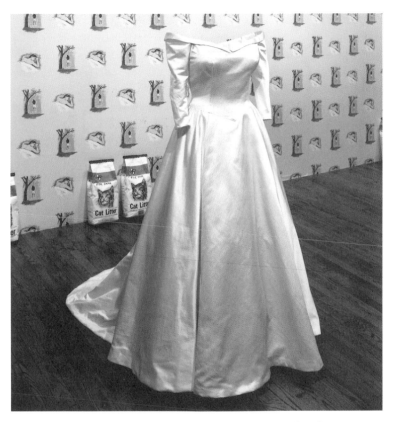

The traumatic: in this 1989 installation Robert Gober evokes the intricacies of fear, desire, and pain in the American imaginary of race and sexuality.

Museum of Art. The installation thus existed in the shadow not only of traumatic history but of significant art; the first helped to charge the second, the second to frame the first, and in the process both were transformed in the reciprocal way noted above.[11] Of

course such "shadowing" by artistic precedents is primordial; it is the primary element that allows any art to be constituted as such, as a discipline that lives on at all. But often the shadowing in contemporary art is more literally *spectral*. It is announced as such in many titles (there are "ghosts" in Paul Auster, Jim Jarmusch, and Rachel Whiteread, to cite but one example in fiction, film, and art); it also operates formally at the level of genre or medium. The shadowing I have in mind has little of the "anxiety of influence" described by Harold Bloom in modernist poetry; yet neither is there much "ecstasy of influence" along the postmodernist lines of the high-spirited meta-fiction of university novelists like John Barth and Robert Coover, or of the homage-laden neo-genre cinema of film-school directors like Martin Scorsese and Brian de Palma.[12] The shadowing in play today is more muted, a sort of outlining and shading, in the manner that *Mrs. Dalloway* (1925) outlines and shades *The Hours* (1998) by Michael Cunningham.[13]

This spectrality informs the recent work of Jim Jarmusch, in particular *Dead Man* (1995) and *Ghost Dog* (2000), both of which exist in the shadow of old genres. In the hire of a minor mobster, "Ghost Dog" is a black assassin who lives according to the ancient code of Japanese warriors; *Ghost Dog*, then, is an amalgam of Gangster and Samurai films that "comes after" these genres in a way that renders both at once archaic and exotic, strangely animated. *Dead Man* has a similar relation to the Western: the story of the westward journey of a young man from Cleveland named William Blake, it is a repository of genre themes from silent Westerns to anti-Westerns: a white man befriended by an Indian guide, an innocent man tracked by murderous bounty-hunters, the West portrayed as a field of rapacious death. If *Dead Man* treats the Western as if from its own afterlife, it is also produced out of the passing of the West; and both its protagonists are spectral as well:

William Blake is mistaken by his native guide "Nobody" for a spirit from the dead – as the great Romantic visionary who must be returned to the after-world. At several levels, then, the film is a spirit-quest of the already-dead. "After the end of history, the spirit comes by *coming back* [revenant]," Derrida writes of the "hauntology" that he deems "the dominant influence on discourse today"; "it figures *both* a dead man who comes back and a ghost whose expected return repeats itself, again and again."[14]

In contemporary art this ghostly persistence is especially strong in the work of Rachel Whiteread. In the late 1980s she began to cast everyday objects like bathtubs and mattresses, closets and rooms, in materials like rubber and resin, plaster and concrete. As the objects are used as molds, the castings are the negative spaces of these things; as a result they are at once obvious in production and ambiguous in reference. For though her sculptures are based on utilitarian objects and everyday sites, they negate function and harden space into mass, and though they appear whole and solid, they also seem fragmentary and spectral. More ambiguously still, these literal traces suggest symbolic traces, memories of childhood, family, and community: they conjure up "the cultural space of the home" as a place of beginnings overwhelmed by endings, as a place haunted by absence.[15] For this reason her work is often associated with the uncanny, that is, with the return of familiar things made strange by repression, and sometimes her death-masks of familial objects and maternal spaces do render the homey *unheimlich*. But in the end they do not evoke the return of the repressed so much as the persistence of the lost: they are less *unheimlich* than homeless in effect. Not only psychological, these castings "carry the marks of history written on the social body."[16] In this regard they too possess the double reflexivity mentioned above: they recall both Minimalist objects and Pop signs, but they render both ghostly – spirits of the social past.

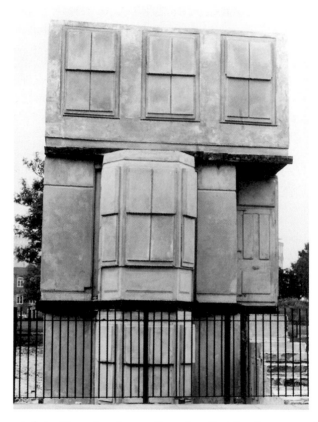

The spectral: in *House* (1993), a casting of an East London terrace house,
Rachel Whiteread uses literal traces to evoke social absences.

This is especially true of her most celebrated work, *House* (1993),
a concrete casting of a terrace house scheduled for demolition in a
working-class neighborhood of East London. Her negative imprint
of these vanished rooms was inscribed not only with the outlines of

window sills, door frames, and utility lines, but also with the traces of past inhabitants; as such it stood in a park for a time like an unrequited ghost. Its great provocation was to connect the psychic and the social in this way, to link "the lost spaces of childhood" with the lost working-class culture of East London, both threatened by rapacious development. Perhaps its opponents grasped this connection – the local council first approved the casting, then voted to demolish it – or perhaps they refused a public sculpture that did not idealize social life or monumentalize historical memory. In any case *House* is a public sculpture that is obdurate in its living-on – though it no longer exists materially.

<div align="center">*</div>

A third strategy in the condition of coming-after is the staging of *nonsynchronous* forms; prominent practices that feature outmoded genres include the slide projections of James Coleman, "the draw-ings for projection" of William Kentridge, the narrative silhouettes of Kara Walker, and the filmic installations of Stan Douglas.[17] The strategy here is to make a new medium out of the remnants of old forms, and to hold together the different temporal markers in a single visual structure. Once more, in the best instances, a double reflexivity is at work: a medium is (re)constituted in a recursive way that is nonetheless open to social content – in a way, moreover, that reminds us that "form" is often nothing but "content" that has become historically sedimented. In his drawings for projection, for example, Kentridge links an old tradition of satirical drawing (Wil-liam Hogarth, Honoré Daumier, George Grosz, Ben Shahn, and so on) with an archaic technique of filmic animation (devices like irises, inter-titles, and musical accompaniment). He synchronizes these nonsynchronous forms, then trains them on occluded aspects of apartheid life in his native South Africa. This artisanal kind of

projected drawing thus points to lost moments in art history (e.g., before the industrialization of cinema) that serve as formal analogues to lost moments in social history – lost in the sense of suppressed, skipped over, or displaced.

"The outmoded" might be too inflected by Surrealist associations to capture this last connection between displaced forms and histories. The Surrealists, Benjamin writes in his 1928 essay on the movement, were

> the first to perceive the revolutionary energies that appear in the "outmoded" [*veraltet*], in the first iron constructions, the first factory buildings, the earliest photos, the objects that have begun to be extinct, grand pianos, the dresses of five years ago, fashionable restaurants when the vogue has begun to ebb from them . . . They bring the immense force of "atmosphere" concealed in these things to the point of explosion.[18]

Such a weird array of things is not the stuff of a renewed medium; on the contrary, it is part of the Surrealist project to "explode" conventional categories of cultural objects. In this way it presumes a reified tabulation of artistic mediums to disrupt – which, as argued elsewhere in this book, is precisely not our problem. There is the further dilemma that "the outmoded" might now be outmoded too, recuperated as a device in the very process that it once seemed to question – the heightened obsolescence of fashion and other commodity lines. Yet one aspect of the outmoded is still valid, the one plied by most of the artists mentioned above, and Surrealism is again a touchstone. "Balzac was the first to speak of the ruins of the bourgeoisie," Benjamin writes in a later comment on the Surrealists. "But only Surrealism exposed them to view. The development of the forces of production reduced the wish symbols of the previous century to rubble even before the monuments

representing them had crumbled."[19] The "wish symbols" here are the capitalist wonders of the nineteenth-century bourgeoisie at the height of its confidence, such as "the arcades and interiors, the exhibitions and panoramas." These structures fascinated the Surrealists nearly a century later – when further capitalist development had turned them into "residues of a dream world" or, again, "rubble even before the monuments which represented them had crumbled." According to Benjamin, for the Surrealists to haunt these outmoded spaces was to tap "the revolutionary energies" that were trapped there. But it may be more accurate (and less utopian) to say that the Surrealists registered the mnemonic signals encrypted in these structures – signals that might not otherwise have reached the present. This deployment of the nonsynchronous pressures the totalist assumptions of capitalist culture, and questions its claim to be timeless; it also challenges this culture with its own wish symbols, and asks it to recall its own forfeited dreams of liberty, equality, and fraternity. It is this mnemonic dimension of the outmoded that might still be mined today.

Of course what counts as the outmoded has changed radically. Not long ago film was the medium of the future; now it is a privileged index of the recent-past, and so a primary element in a nonsynchronous protest against the presentist totality of design culture.[20] In this regard what early arcades were for the Surrealists, early cinema is for contemporary artists like Stan Douglas and Janet Cardiff: a repository of old sensations, private fantasies, and collective hopes – "residues of a dream world." "Both in terms of presentation and the subject matter of my work," Douglas has remarked, "I have been preoccupied with failed utopias and obsolete technologies. To a large degree, my concern is not to redeem these past events but to reconsider them: to understand why these utopian moments did not fulfill themselves, what larger forces kept

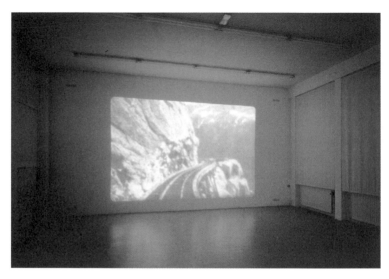

The nonsynchronous: in the film installation *Overture* (1986) Stan Douglas explores the residues of "failed utopias and obsolete technologies."

a local moment a minor moment: and what was valuable there – what might still be useful today."[21] To cite only one instance in his work, *Overture* (1986) is a film installation that combines archival footage from the Edison Company from 1899 and 1901 with audio text from *Remembrance of Things Past* (1913–22). The old film was shot from a camera mounted on a train engine as it passed along cliffs and through tunnels in British Columbia; the Proust is a meditation on the state of semi-consciousness that exists between sleeping and waking. There are six extracts from Proust and three sections of film (with tunnel passages extended by black leader), so that when the footage recurs it is matched with a different text, in a way that tests our sense of repetition and difference, memory

and displacement. *Overture* is concerned not only with the transition from sleeping to waking, with the rebirth of consciousness that is also a return to mortality, but also with "the passing of narrative form from one medium, the novel, to another, film. At this juncture, a utopian possibility simultaneously opens up and shuts down."[22] It juxtaposes moments of rift – in subjective experience as well as in cultural history – when other possibilities of self and expression are glimpsed, lost, and glimpsed again. "Obsolete forms of communication," Douglas has commented, "become an index of an understanding of the world lost to us." To recover these forms is to "address moments when history could have gone one way or another. We live in the residue of such moments, and for better or worse their potential is not yet spent."[23]

If the strategy of the nonsynchronous is to hold together markers of different times, then the strategy of the *incongruent*, the fourth and final one to be mentioned here, is to juxtapose traces of different spaces. I have in mind the hybrid objects and sited tableaux of David Hammons, Jimmie Durham, Felix Gonzalez-Torres, Rikrit Tiravanija, and Gabriel Orozco. Often performative and provisional, this work projects a lyrical kind of criticality: it complicates found things with invented ones, reframes given spaces, and frequently leaves behind enigmatic site-specific souvenirs as it does so.

Above I suggested that the expanded field of postmodernist art has largely imploded, and that the recovered devices of neo-avant-garde art are mostly attenuated. Paradoxically enabled by historical distance and/or geopolitical difference, these artists have turned this imploded field into the departure point for an expansive practice once again, in which certain aspects of both postmodernist and neo-avant-garde art are recovered. For example, like postmodernist "sculpture in the expanded field," this postcolonial sculpture in the

incongruent field is defined, at least initially, in the negative: "Not the monument, not the painting, not the picture," Durham has remarked of his unnamable objects. Rather, like neo-avant-garde artists before him, he seeks an "eccentric discourse of art" that poses "investigatory questions about what sort of thing [art] might be, but always within a political situation of the time."[24] This formulation pertains to the others as well; and, as might be expected, the "investigatory questions" are framed with neo-avant-garde devices that are renewed through displacement and/or estrangement. For instance, Hammons has offered pathetic objects for sale on the street that exist in a parodic relation to commodity exchange (e.g., found doll shoes, snowballs in various sizes), and Tiravanija has made gift offerings in galleries that point to an alternative to the capitalist nexus of art (e.g., his own preparation of Thai dishes). Again a double reflexivity is at a premium here: "what sort of thing [art] might be . . . within a political situation."

Not the monument, not the picture: Gabriel Orozco often mixes these categories with mundane life. He has played subversively with the most traditional of sculptural procedures, such as modeling and cutting.[25] In *Yielding Stone* (1992) he rolled a plasticine ball in the street in such a way as to pick up random bits of urban detritus: here the tradition of modeling was recast as an almost automatist practice, in which the everyday world, not the expressive artist, made the marks. In *La DS* (1993) Orozco shifted not the agency of sculpture but the object. Rather than conventional materials of wood or stone, he cut an old Citroën DS in half, excised a portion, and stuck the two parts together again: here the tradition of carving was reshaped into an almost readymade practice, in which destruction and reclamation were also combined. In this practice of incongruent objects in an imploded field, Orozco may transfer the attributes of one medium to another medium, as in *Yielding Stone*

where the indexicality associated with photography becomes the property of sculpture.[26] So too a sculptural process may prepare a photographic tableau, as in *Island within an Island* (1993) where the (de)compositional strategy of installation art sets up the photograph – in this case a miming of the Lower Manhattan skyline in the background with found debris in the foreground. Folding medium onto medium, space onto space, island onto island, Orozco often wins critical pleasures from the otherwise painful ironies of dislocation and dispersal. After the events of 11 September 2001 this work of subversive mimicry has also taken on new meaning as an image of remembrance, of coming-after and living-on.[27]

The incongruent: *Island within an Island* (1993) by Gabriel Orozco.

NOTES

PREFACE

1. Originals of Chapters 1–4 appeared in *London Review of Books*: 21 September 2000, 5 April 2001, 23 August 2001, 29 September 2001; of Chapter 7 in *New Left Review* (March/April 2001); and of Chapters 5 and 6 in *October* 99 (Winter 2002) and 77 (Summer 1996). I write this preface two weeks after 11 September 2001, at a time when "design and crime" has taken on a new inflection, and political alternatives a special urgency.

1 BROW BEATEN

1. John Seabrook, *Nobrow: The Culture of Marketing, the Marketing of Culture* (New York: Alfred A. Knopf, 2000). Unless otherwise specified, all quotations are from this source. This is how Seabrook glosses "the brow system":

The words *highbrow* and *lowbrow* are American inventions, devised for a specifically American purpose: to render culture into class. H. L. Mencken popularized the brow system in his 1915 book *The American Language*, and the critic and scholar Van Wyck Brooks was among the first to apply the terms to cultural attitudes and practices. 'Human nature itself in America exists on two irreconcilable planes,' he wrote in *The Flowering of New England* (1917), the plane of stark intellectuality and the plane of stark business, planes which Brooks labeled *highbrow* and *lowbrow* respectively. There's more than a whiff in the words of their rank etymological origin in the pseudoscience of phrenology. But the words' roots also underscore the earnestness with which Americans believed in these distinctions: they were not merely cultural, they were biological. In the United States, making hierarchical distinctions about culture was the only acceptable language people had for talking openly about class. In less egalitarian countries, like [Tina] Brown's homeland, a class-based social hierarchy existed before a cultural hierarchy evolved, and therefore people could afford to mix commercial and elite culture – Monty Python, for example, or Tom Stoppard, or Laurence Olivier – without seriously threatening their position as members of the upper class. But in the United States, people needed highbrow–lowbrow distinctions to do the work that social hierarchy did in other countries. Any rich person could buy a mansion, but not everyone could cultivate a passionate interest in Arnold Schönberg or John Cage.

2. A little background on *The New Yorker* may be helpful here. In 1985 Si Newhouse, the mogul of the Condé Nast media empire (*Vogue*, *GQ*, etc.), purchased the magazine from its founding family – to scatter some of its aura on his other publications, or so it was thought at the time. Newhouse (a perfect Dickensian name for his role in this story) pledged to change nothing at *The New Yorker*, but in 1987 he fired its longtime editor, the mystically remembered "Mr. Shawn" (it was revealed after his death that his first name was William). This shocked more people than it should have, for the magazine had a problem: it did not make money. In fact by 1987 it was $12 million a year in the red – a high price-tag for respectability, even for a mega-rich guy. Newhouse wanted both respectability and profitability, and he turned to Robert Gottlieb, editor-in-chief at the

prestigious publishing house of Alfred A. Knopf (publisher of *Nobrow*, for those keeping score), as the man to make this cocktail swirl. In a retrospect that is easy but exact, Seabrook sees Gottlieb as a transitional figure with a compromise strategy – to use camp, "a way of being hierarchically nonhierarchical," to reconcile "highbrow connoisseurship" and "lowbrow pursuits" (e.g., Hollywood divas, Miami Beach), respectability and profitability. But the compromise did not work well or for long – respectability went down, profitability did not go up – and Gottlieb was axed in 1992, at which time Newhouse moved Tina Brown over from the editorship of *Vanity Fair*. Immediately she embraced the mass culture that Shawn and company had so long shunned. (Seabrook tells a funny story of role reversal with Steven Spielberg, who asks to see the library. "'The library!' exclaimed Tina. 'Wonderful! . . . Where's the library?'") At the end of 1997 Brown was replaced by the less-Buzz-happy David Remnick.

3. More amusing stories in this regard: in one scene his dapper dad tears up Ralph Lauren Polo ads, enraged at the mass-marketing of *his* style; in another, young Seabrook is miffed when the Lauren ad people pass him up for a shoot of preppie Princeton rowers even though *he* is the real thing.

4. There is a rival account of this thesis that is thoroughly neocon. Written by the ex-*Wall Street Journal* reporter David Brooks and blurbed by the usual suspects from Tom Wolfe to Christopher Buckley, it is titled *Bobos in Paradise* – Bobos for "bourgeois bohemians." Its argument, which confuses cappuccino with bohemia, and a pension-plan invested in money-markets with a political sell-out, is as follows:

> Marx told us that classes inevitably conflict, but sometimes they just blur. The values of the bourgeois mainstream culture and the values of the 1960s counter-culture have merged. That culture war has ended, at least within the educated class. In its place that class has created a third culture, which is a reconciliation between the previous two. The educated elites didn't set out to create this reconciliation. It is the product of millions of individual efforts to have things both ways. But it is now the dominant tone of our age. In the resolution between the culture and the counter-culture, it is impossible to tell who co-opted whom, because in reality the bohemians and the bourgeois co-opted each other. They emerge from this process as bourgeois bohemians, or Bobos.

5. See Horkheimer and Adorno, *Dialectic of Enlightenment*, trans. John Cumming (1949; New York: Continuum, 1969).

6. See Guy Debord, *Comments on the Society of the Spectacle*, trans. Malcolm Imrie (London: Verso, 1990); and Annette Michelson, ed., *Andy Warhol* (Cambridge: MIT Press/October Files, 2001). Also see Chapter 5.

2 DESIGN AND CRIME

1. Adolf Loos, "Ornament and Crime," in Ulrich Conrads, ed., *Programs and Manifestoes on 20th-Century Architecture* (Cambridge: MIT Press, 1970), p. 20.

2. Loos, "The Poor Little Rich Man," in *Spoken into the Void: Collected Essays 1897–1900*, trans. Jane O. Newman and John H. Smith (Cambridge: MIT Press, 1982), p. 125. Unless otherwise specified, all quotations are from this source.

3. Karl Kraus, *Die Fackel* (December 1912), p. 37, reprinted in *Werke*, vol. 3 (Munich: Kösel Verlag, 1952–66), p. 341. See Carl Schorske, "From Public Scene to Private Space: Architecture as Culture Criticism," in *Thinking with History* (Princeton: Princeton University Press, 1998).

4. Walter Benjamin, "Paris, Capital of the Nineteenth Century," in *Reflections*, trans. Edmund Jephcott (New York: Harcourt Brace Jovanovich, 1978), p. 155.

5. Jean Baudrillard, *For a Critique of the Political Economy of the Sign*, trans. Charles Levin (St. Louis: Telos Press, 1981), p. 186.

6. See Ash Amin, ed., *Post-Fordism: A Reader* (Oxford: Blackwell, 1994).

7. Bruce Mau *et al.*, *Life Style* (London: Phaidon Press, 2000). Unless otherwise specified, all quotations are from this source.

8. Many young "Deleuzian" artists and architects seem to misunderstand this basic point, as they take up a "capitalogical" position as if it were a critical one.

9. Benjamin, pp. 154–55. I mean this trope of "master builder" to resonate in Chapter 3.

10. Robert Musil, *The Man Without Qualities*, trans. Sophie Wilkins (New York: Vintage, 1995), vol. 1, pp. 158–59.

3 MASTER BUILDER

1. This is how Beatriz Colomina puts it in her essay in Jean-Lous Cohen, ed., *Frank Gehry: The Art of Architecture* (New York: Abrams, 2001), the book that accompanied the recent retrospective at the Guggenheim New York and Bilbao. Unless otherwise specified, all quotations are from this source.

2. See Kenneth Frampton, "Towards a Critical Regionalism," in Hal Foster, ed., *The Anti-Aesthetic: Essays on Postmodern Culture* (New York: New Press, 1983).

3. See the text by Jean-Lous Cohen in *Frank Gehry*.

4. Robert Venturi, Denise Scott-Brown, and Steven Izenour, *Learning from Las Vegas* (Cambridge: MIT Press, 1972), p. 87.

5. Carl Andre on WBAI-FM, New York, 8 March 1970, as transcribed in Lucy R. Lippard, *Six Years: The Dematerialization of the Art Object* (New York: Praeger, 1973), p. 156.

6. See Fredric Jameson, *Postmodernism, or the Cultural Logic of Late Capitalism* (Durham: Duke University Press, 1991).

7. See Sigmund Freud, "Formulations Regarding the Two Principles in Mental Functioning" (1911).

8. Meyer Schapiro, *Worldview in Painting – Art and Society* (New York: George Braziller, 1999), p. 124.

9. Ibid., p. 128.

10. Guy Debord, *The Society of the Spectacle*, trans. Donald Nicholson-Smith (New York: Zone Books, 1994), p. 24.

4 ARCHITECTURE AND EMPIRE

1. Rem Koolhaas, *Delirious New York* (New York: Oxford University Press, 1978), pp. 6, 242.

2. Ibid., pp. 13, 15–16, 244.

3. Charles Baudelaire, *The Painter of Modern Life and Other Essays*, trans. Jonathan Mayne (London: Phaidon Press, 1964), p. 13.

4. Robert Venturi, Denise Scott-Brown, and Steven Izenour, *Learning from Las Vegas* (Cambridge: MIT Press, 1972), p. 6. His comments on postmodern architecture are properly severe: "In the seventies, architects wallowed ... in fantasies of control. Looking back at history they rediscovered ... old forms, a new erudition arrested at the first page of the history book – the door, the column, the architrave, the keystone ..." (*S, M, L, XL* [New York: Monacelli Press, 1995], p. 937). But he also became impatient with deconstructivist architecture: "A disproportionate part of its energy is used in constructing systems of impossibility." A more difficult antagonist for Koolhaas would be Manfredo Tafuri, whose *Architecture and Utopia*, a critique of modernist utopia as tabula rasa for capitalist development, appeared in 1973, five years before *Delirious New York*.

5. *S, M, L, XL*, p. 667.

6. Ibid., pp. 510, 515.

7. Koolhaas repeats this phrase several times in his writing; eg., ibid., p. 937.

8. This is the cover copy of *S, M, L, XL*, which marshals images no longer as indices as history (as in *Delirious New York*) so much as elements of design (see Chapter 2).

9. *Delirious New York*, p. 203. Also see the 1985 text with the Daliesque title "The Terrifying Beauty of the Twentieth Century" in *S, M, L, XL*. Freud associated paranoia with religion, but he might have added theory, especially wild theory of the sort practiced by Koolhaas (among many others).

10. Francine Fort *et al.*, eds, *Mutations* (Bordeaux: ACTAR, 2000), pp. 4, 6. I refer to the extracts published here since the final versions of *Shopping* and *Great Leap Forward* were not yet available.

11. Koolhaas quoted in *Progressive Architecture* (January 1991), reprinted in *S, M, L, XL*, p. 578.

12. This description of The Project on the City opens both *The Harvard Design School Guide to Shopping* and *Great Leap Forward* (New York: Taschen, 2001), written and edited by Rem Koolhaas, Chuihua Judy Chung, Jeffrey Inaba, Sze Tsung Leong *et al. S, M, L, XL* contains studies of Atlanta and Singapore as well as such texts as "Whatever Happened to Urbanism" and "The Generic City," but the contemporary city is the sole subject of The Project.

13. See Michael Hardt and Antonio Negri, *Empire* (Cambridge: Harvard University Press, 2001).
14. *Mutations*, p. 136.
15. Ibid., p. 152.
16. Ibid., p. 176.
17. *S, M, L, XL*, p. 200.
18. Koolhaas, "Pearl River Delta," in Catherine David, ed., *Documenta X: The Book* (Ostfildern-Ruit: Hatje Cantz Verlag, 1997).
19. *S, M, L, XL*, p. 847. At times Koolhaas seems to point to a post-Fordist version of the "left-Fordism" once advocated by Gramsci, Benjamin, and many others, a go-for-broke strategy that looks through and beyond this mode of production. It is not likely to be any more successful than this original position. As it is, Koolhaas sometimes seems to turn a Deleuzian critique of schizophrenic capitalism into a positive kind of cultural program of its own; he is not alone here.
20. Walter Benjamin, *The Arcades Project*, trans. Howard Eiland and Kevin McLaughlin (Cambridge: Harvard University Press, 1999), p. 459.
21. "Much of it implies 'architectural' thinking without necessarily the need to build," Koolhaas has remarked. "It's about organization, strategies, identity ... We are coming closer to being an office that can intervene anywhere in contemporary culture" ("A Conversation with Rem Koolhaas and Sarah Whiting," *Assemblage* 40 [December 1999], p. 55).
22. In this respect his notes during the 1989 Paris library competition are telling: "Suddenly nauseated by the apparent obligation of 'my' profession to fabricate differences, to 'create' interest, to deal with the apparently infinite boredom out there, to invent. Why me? Why not everybody else?" (*S, M, L, XL*, p. 616).
23. Baudelaire, *Intimate Journals*, trans. Christopher Isherwood (San Francisco: City Lights Books, 1983), p. 53. The desperation noted in my next sentence also speaks through the disguise of another Baudelaire line, from *Les Fleurs du Mal*, that Koolhaas has taken as a kind of motto: *"Les charmes de l'horreur n'enivrent que les forts."*
24. *Assemblage*, p. 50. On 11 September "everything" changed once again, and more than ever we need designers able to reinvent the "relationship between the formal and the social" in non-defensive ways.

5 ARCHIVES OF MODERN ART

1. Michel Foucault, *The Archaeology of Knowledge* (1969; New York: Harper Books, 1976), p. 129. Unlike Foucault, however, I want to put these archives into historical motion; my emphasis will be on the shifts between them.

2. I borrow the first term from Michael Fried (see note 4) and the second from Susan Buck-Morss in her *Dialectics of Seeing: Walter Benjamin and the Arcades Project* (Cambridge: MIT Press, 1989).

3. Charles Baudelaire, "The Salon of 1846," in Jonathan Mayne, ed., *The Mirror of Art: Critical Studies of Charles Baudelaire* (Garden City, NY: Doubleday Anchor Books, 1956), p. 83.

4. See Michael Fried, "Painting Memories: On the Containment of the Past in Baudelaire and Manet," *Critical Inquiry* 10, no. 3 (March 1984), pp. 510–42; also see his *Manet's Modernism, or the Face of Painting in the 1860s* (Chicago: University of Chicago Press, 1996). I am indebted to "Painting Memories" throughout the next few paragraphs.

5. I prefer the term "survival" as a living-on of such meanings, a *Nachleben* or "afterlife" in the sense of Aby Warburg (more on which below). Christopher Pye pointed out to me that both the Géricault and the Delacroix thematize surviving as well, and Eduardo Cadava that a buried meaning of "tradition," perhaps relevant here, is "betrayal."

6. Might some of the mnemonics that Frances Yates traced from antiquity to the Renaissance in her classic *The Art of Memory* (London: Routledge, Kegan and Paul, 1966) be continued in the modern museum?

7. Fried, "Painting Memories," pp. 526–30.

8. Baudelaire, 1865 letter to Manet, in *Correspondance*, 2 vols. (Paris, 1973), vol. 2: p. 497. In some respects Jeff Wall returns to this crux in Manet, and claims it as the dynamic of his own pictorial practice.

9. On this Oedipal structure in nineteenth-century French painting see Norman Bryson, *Tradition & Desire: from David to Delacroix* (Cambridge: Cambridge University Press, 1984), and Thomas Crow, *Emulation: Making Artists in Revolutionary France* (New Haven: Yale University Press, 1995).

10. Theodor W. Adorno, *Prisms*, trans. Samuel and Shierry Weber (Cambridge: MIT Press, 1981), p. 177.

11. Ibid., p. 175.

12. Ibid., p. 179; Marcel Proust, *A l'Ombre des jeunes filles en fleurs*, 2 vols (Paris: Editions Gallimard), vol. 2: pp. 62–63. This brief reflection on the museum comes in the midst of a long meditation on departures and arrivals, on de-contextualizations and re-contextualizations and their effects on habit and memory. "In this respect as in every other," Proust writes, "our age is infected with a mania for showing things only in the environment that belongs to them, thereby suppressing the essential thing, the act of mind which isolated them from that environment."

13. Ibid.

14. Georg Lukács, *History and Class Consciousness*, trans. Rodney Livingstone (Cambridge: MIT Press, 1986), p. 110.

15. On memory crises see Richard Terdiman, *Present Past: Modernity and the Memory Crisis* (Ithaca: Cornell University Press, 1993). In "Tradition's Destruction: On the Library of Alexandria" *October* 100 (Spring 2002) Daniel Heller-Roazen argues that mnemonic loss is foundational to the archive (both library and museum), not catastrophic to it, that memory crisis is its natural *raison d'être*. But these crises also occur only at particular pressure points in history (more on which below).

16. The late work of Alois Riegl – the Riegl of "The Cult of Monuments" (1903), say – might serve as well here.

17. Not to mention, in the case of Wölfflin especially, in the name of original work, singular subjectivity, national culture, and so on.

18. Heinrich Wölfflin, *Principles of Art History: The Problem of Development of Style in Later Art*, trans. M. D. Hottinger (New York: Dover, 1950), p. 229. This is not only the Hegelian sentiment that art is "a thing of the past" and that art history is belated by definition. What is at issue here is the redemptive logic inscribed in the dialectic of reification and reanimation (more on which below).

19. Martin Warnke, "On Heinrich Wölfflin," *Representations* 27 (Summer 1989), p. 176.

20. 1915 is the year that Malevich exhibits his early Suprematist paintings and Tatlin his early Constructivist reliefs, two initial attempts to overthrow

style-discourse altogether, especially its encoding of bourgeois forms of production and reception; the year that Duchamp finds his "readymade" term in New York, a model of art that mocks style-discourse, especially its encoding of singular subjectivity and original work; and the year that Picasso reverts to drawing à la Ingres, that is, to a kind of postmodern pastiche *avant la lettre* that complicates any historicist narrative of styles (far more so than the nineteenth-century eclecticism that worried Wölfflin). Yet if Wölfflinian formalism could not address avant-garde art, some of its legatees felt that it might be adapted to "modernist painting," first French, then American. For example, Greenberg and Fried extracted a "dialectic of modernism" from such painting that is expressly Wölfflinian. It was driven by the same dynamic of palling in perception and problem-solving in form that Wölfflin saw at work in his history of styles, and it too was pledged to the reanimation of art and vision against reification – against the reification of "kitsch" (for Greenberg) and "theatricality" (for Fried), that is to say, of mechanical reproduction and commodity culture – again, all in the service of formal unity and historical continuity. On the "dialectic of modernism" see Fried, *Three American Painters: Kenneth Noland, Jules Olitski, Frank Stella* (Cambridge: Fogg Art Museum, 1965), reprinted in *Art and Objecthood* (Chicago: University of Chicago Press, 1998).

21. We face neither the fascist threat nor the world war that Wölfflin and Warburg faced, but there are some parallels to the crisis of nearly a century ago: a far deeper challenge to the Eurocentric tradition, an equally dramatic transformation of the technological bases of society, a greater extension of capitalist Empire, and so forth – certainly enough to provoke a renewed anxiety about the memory-structure of artistic practices and historical discourses today. This anxiety is effectively treated – not merely acted out – in two recent interventions in art-historical methodology: *The Judgment of Paris* by Hubert Damisch, which traces a "judgment" specific to art history, and *The Intelligence of Art* by Thomas Crow, which registers an "intelligence" specific to art; see *The Judgment of Paris*, trans. John Goodman (1992; Chicago: University of Chicago Press, 1996), and *The Intelligence of Art* (Chapel Hill: University of North Carolina Press, 1999). In different ways both authors are concerned with a transformational

logic not immanent to art but nonetheless particular to it. Hence, they do not view art as autonomous but they do see art history as distinctive. And the spirit of Warburg hovers over both texts, explictly in the Damisch. In terms of disciplinary models today, Wölfflin in his formalist guise is beyond the pale; so is Panofsky, at least in his iconographic guise, at least for the modernist field. Riegl was called up, because of his interest in marginal forms and neglected periods, in the service of canon-critique during the postmodernist heyday, so there already exists a late Riegl industry. But Warburg has become attractive for reasons beyond the process of elimination. Certainly his personal troubles speak to our traumatophilic times, as does his deep interest in the mnemonic survival of the image, however problematic his near-conflation of the mnemonic and the traumatic might be. More important is his broad method that offers an interdisciplinarity within art history that touches on concerns, both psychoanalytical and anthropological, that extend the discipline as well.

22. Erwin Panofsky, *Meaning in the Visual Arts* (Chicago: University of Chicago Press, 1955), p. 19.

23. Ibid., p. 24. This formulation speaks to a Hegelian preoccupation of the discipline: how great art can be both "a thing of the past" and available to contemporary consciousness. On this point see Michael Podro, *The Critical Historians of Art* (New Haven: Yale University Press, 1982), especially the introduction.

24. Walter Benjamin, *Illuminations*, ed. Hannah Arendt (New York: Schocken Books, 1969), p. 255.

25. Ibid., p. 224.

26. Siegfried Kracauer, *The Mass Ornament*, trans. and ed. Thomas Y. Levin (Cambridge: Harvard University Press, 1995), p. 81. Warburg bridges our second and third archival relations; and to deepen the third one I have associated here with Benjamin and Panofsky, a pairing of Kracauer and Warburg, who complement each other uncannily on the relation between the photographic and the mnemonic, should be developed – but Benjamin Buchloh has already done so, brilliantly, in "Gerhard Richter's *Atlas*: The Anomic Archive," *October* 88 (Spring 1999).

27. Ibid., p. 257.

28. On this relation see Denis Hollier, "On Paper," in Cynthia Davidson, ed., *Anymore* (New York: Any Foundation, 2001). Also see Rosalind Krauss, "Postmodernism's Museum without Walls," in Reesa Greenberg *et al.*, *Thinking about Exhibitions* (New York: Routledge, 1996). The "museum without walls" is the unfortunate translation of *le musée imaginaire*. For a contemporaneous critique of the notion see Georges Duthuit, *Le musée inimaginable* (Paris: Librairie José Corti, 1956).

29. Yet this too is implicit in the "Artwork" essay, though most commentators overlook it. "At the time of its origin a medieval picture of the Madonna could not yet be said to be 'authentic'," Benjamin writes in a footnote. "It became 'authentic' only during the succeeding centuries and perhaps most strikingly so during the last one" (*Illuminations*, p. 243).

30. André Malraux, *The Voices of Silence*, trans. Stuart Gilbert (Princeton: Princeton University Press, 1978), p. 112.

> All that remains of Aeschylus is his genius. It is the same with figures that in reproduction lose both their significance as objects and their function (religious or other); we see them only as works of art and they bring home to us only their maker's talent. We might almost call them not 'works' but 'moments' of art. Yet diverse as they are, all these objects . . . speak for the same endeavor; it is as though an unseen presence, the spirit of art, were urging all on the same quest, from miniature to picture, from fresco to stained-glass window, and then, at certain moments, it abruptly indicated a new line of advance, parallel or abruptly divergent. Thus it is that, thanks to the rather specious unity imposed by photographic reproduction on a multiplicity of objects, ranging from the statue to the bas-relief, from bas-reliefs to seal-impressions, and from these to the plaques of the nomads, a 'Babylonian style' seems to emerge as a real unity, not a mere classification – as something resembling, rather, the life-style of a great creator. Nothing conveys more vividly and compellingly the notion of a destiny shaping human ends than do the great styles, whose evolutions and transformations seem like long scars that Fate has left, in passing, on the face of the earth.

31. Ibid., p. 13. Malraux is hardly alone in this totalizing mode; this was a moment for grand speculations on art and architecture by Siegfried

Giedion, Gyorgy Kepes, Henri Focillon, Joseph Schillinger, Alexander Dorner, among others.

32. It is no accident that my narrative of archival relations matches, loosely, the periodizations of spectacle proposed by Guy Debord, T. J. Clark, and Jonathan Crary.

33. Michel Foucault, "Fantasia on the Library" (1967), in *Language, Counter-Memory, Practice* (Ithaca: Cornell University Press, 1977), pp. 92–93.

34. Jean Baudrillard, *For a Critique of the Political Economy of the Sign*, trans. Charles Levin (St. Louis: Telos Press, 1981), p. 186. The most trenchant account of this dialectic remains Manfredo Tafuri, *Architecture and Utopia: Design and Capitalist Development*, trans. Barbara Luigia La Penta (1973; Cambridge: MIT Press, 1979). On the "mediation" of modern architecture, see Beatriz Colomina, *Privacy and Publicity: Modern Architecture as Mass Media* (Camrbidge: MIT Press, 1994). Also see Chapter 2.

35. In some ways the contemporary museum (the Guggenheim is the flagship of this new fleet) reconciles in perverse fashion the dialectical opposition first presented by Malraux and Benjamin. On the one hand, a version of what Malraux imagined, the virtual Museum without Walls, has become a reality with the electronic museum, the museum on-line. On the other hand, a version of what Benjamin foresaw, a cinema beyond the museum, is now brought back within the museum in the form of exhibition designs calculated to flow cinematically, or to stream like webpages. In this way, too, the institution of art continues to conform to new structures of exchange, to be reformatted around the visual–digital paradigm of the website. And many artists and architects have followed suit, either affirmatively or critically – though what might constitute critique in this context is not yet clear.

6 ANTINOMIES IN ART HISTORY

1. See M. M. Bakhtin/P. M. Medvedev, *The Formal Method in Literary Scholarship*, trans. Albert J. Wehrle (Cambridge: Harvard University Press, 1985), pp. 41–53. On the disputed authorship of this text see the foreword by Wlad Godzich.

2. Of course the art-historical recognition of other *Kunstwollens* was partial at best, and they were often sublated into Hegelian narratives centered on Western art.

3. Clement Greenberg, "Modernist Painting," *Art and Literature* 4 (Spring 1965), p. 199. Also see note 20 of Chapter 5.

4. André Malraux, *The Voices of Silence*, trans. Stuart Gilbert (Princeton: Princeton University Press, 1978), p. 13. Malraux often repeats this celebration: "The Middle Ages were as unaware of what we mean by the word 'art' as were Greece and Egypt, who [*sic*] had no word for it. For this concept to come into being, works of art needed to be isolated from their functions. What common link existed between a 'Venus' which *was* Venus, a crucifix which *was* Christ crucified, and a bust? But three 'statues' can be linked together" (p. 53).

5. Often this ontological assumption was extended to mediums that defied it, such as film, which now seems to disappear, in its past, into related forms of popular attractions and, in its present, into new forms of digital technologies.

6. Michael Podro, *The Critical Historians of Art* (New Haven: Yale University Press, 1982). Often the difference between semiotic and social–historical methods is understood as another version of this split (which it is not).

7. Claude Lévi-Strauss, *Introduction to the Work of Marcel Mauss* (1950), trans. Felicity Baker (London: Routledge & Kegan Paul, 1987), pp. 60–63. Like the primal murder of the father in Freud, this origin is obviously heuristic, outside the very system that it founds.

8. Ibid., p. 55.

9. There are many variations of this opposition – psychological or social, structure or history, Freud or Marx, Lacan or "the historicists" – and many attempts to reconcile it. Perhaps, as it predetermines all versions, the opposition is the problem, and often a theory is most productive when it breaks down this opposition, or when its own oppositional structure breaks down.

10. Erwin Panofsky, "The Concept of Artistic Volition" (1920), *Critical Inquiry* (Autumn 1981).

11. In both cases a figure of agency is smuggled in to animate either text or context and so to connect the two. Drawn from Ernst Cassirer, "symbolic

form" is developed by Panofsky in early texts like "The History of the Theory of Human Proportions as a Reflection on the History of Styles" (1921) and "Perspective as Symbolic Form" (1924–25).

12. Heinrich Wölfflin, *Principles of Art History* (1915), trans. M. D. Hottinger (New York: Dover, 1950), p. 1.

13. This is not to question that significant differences are registered by these terms but to ask how they are registered. Was there an Aryan motive in the nineteenth-century reformulation of art history as a discipline, as there was, according to Martin Bernal, in the nineteenth-century reformulation of classics as a discipline? See his *Black Athena* (New Brunswick: Rutgers University Press, 1987).

14. Michael Baxandall, *Painting and Experience in Fifteenth-Century Italy* (Oxford: Oxford University Press, 1972), unpaginated preface. Apart from its importance I refer to Baxandall because of his sensitivity to the significant difficulties of terms and lexicons.

15. Ibid., pp. 1, 2.

16. For example, the gendering of the subject is remarked, almost automatically now, but only as a social construction; rarely acknowledged is the intransigence of a sexuality, an unconscious, or any other "substance" that might exceed the historically specific.

17. There is a rough division in visual studies between projects concerned à la new historicism with the genealogy of the subject, and projects concerned à la cultural studies with popular media and subcultural expressions, to which I turn now.

18. Of course cultural studies is not a singular entity, divided as it is by its different formations in Britain and North America. For a representative anthology see Cary Nelson *et al.*, *Cultural Studies* (New York: Routledge, 1992). For an overview of visual studies see Nicholas Mirzoeff, *An Introduction to Visual Culture* (New York: Routledge, 1999).

19. Recent studies of Riegl include Margaret Iversen, *Alois Riegl: Art History and Theory* (Cambridge: MIT Press, 1993), and Margaret Olin, *Forms of Representation in Alois Riegl's Theory of Art* (University Park: University of Pennsylvania Press, 1992). Recent translations of Warburg include *The Renewal of Pagan Antiquity*, ed. Kurt Forster (Los Angeles: Getty Research Institute, 1998), and *Images from the Region of the Pueblo Indians of North*

America, trans. and ed. Michael P. Steinberg (Ithaca: Cornell University Press, 1995).

20. Norman Bryson, Michael Ann Holly, and Keith Moxey, the editors of *Visual Culture: Images and Interpretations* (Hanover: University Press of New England, 1994), propose "history of images" in the Introduction. In "What do Pictures *Really* Want?", *October 77* (Summer 1996), W. J. T. Mitchell substitutes "the study of human visual expertise." For critiques of the initial version of my critique here (also published in *October 77*), see Douglas Crimp, "Getting the Warhol We Deserve: Cultural Studies and Queer Culture," *Visual Arts and Culture*, vol. 1, part 2 (1999), and Keith Moxey, *The Practice of Persuasion: Paradox and Power in Art History* (Ithaca: Cornell University Press, 2001). In *Picture Theory* (Chicago: University of Chicago Press, 1994), Mitchell writes of a "pictorial turn."

21. I discuss this problem in art practice in "The Artist as Ethnographer" in *The Return of the Real* (Cambridge: MIT Press, 1996).

22. Marshall Sahlins, *The Critique of Practical Reason* (Chicago: University of Chicago Press, 1976).

23. This is a reductive account of anthropology, I admit, but these exchanges *are* reductive. They seem to follow a used-car principle of discourse. First some anthropologists adapted poststructuralist methods from literary criticism to reformulate culture as *text* – just when literary criticism had worn out this model. Then some literary critics adapted ethnographic methods to reformulate texts as *cultures* writ small – just when anthropology was about to trade in this model for others that focus on the state, legal codes, and so on. This interdisciplinary exchange of damaged goods prompts an obvious question: if the textual and ethnographic turns pivoted on a single model, how *inter*disciplinary could the results be? More specifically, if cultural studies, new historicism, and visual studies often smuggle in an ethnographic model (when not a sociological one), might it be "the *common theoretical ideology* that silently inhabits the 'consciousness' of all these specialists ... oscillating between a vague spiritualism and a technocratic positivism"? (Louis Althusser, *Philosophy and the Spontaneous Ideology of the Scientists and Other Essays* [London: Verso, 1990], p. 97). In the initial version of this text I wrote of a "culture envy"; in *Academic Instincts* (Princeton: Princeton

University Press, 2001) Marjorie Garber writes of the general phenom-
enon of "discipline envy."

24. This is the tendency of Fredric Jameson in *The Cultural Turn* (London: Verso, 1998), and I admit to it too.

25. Barbara Stafford, *Body Criticism* (Cambridge: MIT Press, 1991).

26. Stafford, *Good Looking: Essays on the Virtue of Images* (Cambridge: MIT Press, 1996), cover copy. Also see her *Visual Analogy: Consciousness as the Art of Connecting* (Cambridge: MIT Press, 1999).

27. Stafford, *Body Criticism*, pp. 475, 472.

28. This hypostasizing of the visual is already active in art history, not only in its technology (again, the photographic abstraction into style: *le musée imaginaire*) but also in its teleology, for, in one quasi-Rieglian account, the story of art is a long, complicated sublimation of the tactile into the optical. Here again modernist art is not necessarily opposed to art history, for, in one formalist account, this art also works to purify the pictorial in terms of the optical – that is, to map the impressions of the retina onto the support of the picture (e.g., the painting of Robert Delaunay). Apart from its artistic interest, this purity has a social function: to save modernist art from its corrupt double, mass culture. Yet the rarefying of optical effects and the fetishizing of visual signifers are hardly foreign to capitalist spectacle; they are fundamental to it. So too, visual studies might advance more than resist further hypostasizing of the visual and disembodying of the viewer today. The inadvertent doubling of spectacular culture by postwar painting was first remarked by Leo Steinberg in *Other Criteria* (New York: Oxford University Press, 1972), but also see Rosalind Krauss, *The Optical Unconscious* (Cambridge: MIT Press, 1993).

29. Martin Heidegger, *The Question Concerning Technology and Other Essays*, trans. William Lovitt (New York: Harper & Row, 1977), p. 133. This humanist "mans the realm of human capability as a domain given over to measuring and executing, for the purpose of gaining mastery over that which is as a whole" (p. 132).

30. Mario Perniola, *Enigmas*, trans. Christopher Woodall (London: Verso, 1995), pp. 65–66.

31. Perhaps the primary myth of this world is "interactivity"; in relation to the museum this is sold to us as a capacity to explore its galleries from a

distance, to scan information about its collection, and so on. But this relation is less interactive than "interpassive."

32. Over the last few decades the sciences have retooled around biology, and the priorities of institutions like universities have followed suit: like physics before it, biology is the straw that now stirs the drink.

33. Anthony Vidler, "Warped Space: Architecture and Anxiety in Digital Culture," Power Institute Lecture, University of Sydney, 2000.

> Ostensibly, there is little to distinguish Alberti's [perspectival] window from a computer screen, as there is to differentiate an eighteenth-century axonometric by Gaspard Monge from a wire-frame dinosaur generated by Industrial Light and Magic. What has changed, however, is the technique of simulation and, even more importantly, the place or position of the subject or traditional 'viewer' of the representation. Between contemporary virtual space and modernist space there lies an aporia formed by the auto-generative nature of the computer program and its real blindness to the viewer's presence. In this sense, the screen is not a picture, and certainly not a surrogate window, but rather an ambiguous and unfixed location for a subject.

34. One danger vis-à-vis the museum is this: the museum is not only a repository of different objects; it is also an archive of different regards or gazes, and they too might be flattened in the transformation into information.

35. Michel Foucault, *The Order of Things: An Archaeology of the Human Sciences* (New York: Random House, 1970), p. xv.

36. Ibid., p. xvi.

37. Speaking for Being, Heidegger would regard this Alexandrian archive as the epitome of "the standing-reserve" fundamental to all technology, of which "man in the midst of objectlessness is nothing but the orderer." Speaking for the Old World, a George Steiner might see it as the manifest destiny of America, the land not of open territories but of museum-malls that simulate the remnants of European cultures. But one need hardly agree with these arch-conservatives. Moreover, this Alexandrianism is hardly complete, and it may permit other uses (and abuses) not yet foreseen. So too, as Greenberg argued long ago in "The Avant-Garde and Kitsch" (1939), "the avant-garde moves while Alexandrianism stands still.

And this, precisely, is what justifies the avant-garde's methods and makes them necessary." This remains the case today, even if the terrain of engagement has changed. See Heidegger, *The Question Concerning Technology*, p. 27; George Steiner, "The Archives of Eden," *Salmagundi* 50–51 (Fall 1980–Winter 1981); Clement Greenberg, *Art and Culture* (Boston: Beacon Press, 1961), p. 8.

All these tropes are Orientalist – the "Chinese encyclopedia" in Borges and Foucault, my "new Alexandria," the "Egyptian effect" in Perniola (this one runs back, in photography and film studies, to André Bazin on the "mummy-effect" of these mediums). That is, they project a deathliness elsewhere, when this deathliness is uncannily alive in the West. In "Literature Considered as a Dead Language" Denis Hollier argues "that the regime of the uncanny within which postmodernism operates is the very definition of classicism." Even neo-national literatures that advance a romantic model of oral traditions cannot escape the classical status of dead languages: "Let us call it the irreality effect: the numbing citationality that gives rise to a kind of generalized Pompeiization" (in Marshall Brown, ed., *The Uses of Literary History* [Durham: Duke University Press, 1995], pp. 233–41). This "irreality effect," this undead quality, is also foregrounded, technically and thematically, in much digital photography today (I have in mind recent works by Jeff Wall and Andreas Gursky, among others), in which uncanniness becomes almost routinized.

As suggested above, a principal manifestation of this new Alexandrianism is the posthistorical presupposition of much art production, reception, and exhibition. In this default at the museum, iconography and thematics return, and the only "disruptive" gestures are idiosyncratic hangings. But there is no longer any narrative norm to disrupt, chronological or otherwise; indeed this kind of "disruption" *is* the norm – another version of a rampant routinization. For many this is a good thing: it permits diversity. But, from another angle, it abets a flat indifference, a stagnant incommensurability, precisely a new Alexandrianism. I don't lament the old historicist dimension of art museum and art history; but I don't like the present posthistorical options either. As it is, we often seem swamped by the double wake of modernism and postmodernism (more on which in Chapter 8).

38. See Podro, *The Critical Historians of Art*, passim.

39. Walter Benjamin, Letters to Fritz Radt (dated "Munich, November 21, 1915" and "Munich, December 4, 1915," the year in which *Principles of Art History* was published), cited in Thomas Y. Levin, "Walter Benjamin and the Theory of Art History," *October* 47 (Winter 1988), p. 79.

40. Michael Fried, *Three American Painters: Kenneth Noland, Jules Olitski, Frank Stella* (Cambridge: Fogg Art Museum, 1965), p. 9. As defined here, this "alert" sense of autonomy seems more compensatory than dialectical; it also seems to be undercut by the very "conviction" that, according to Fried, modernist art must also inspire in the subject. That is, conviction suggests a dependence on the art object, even a devotion to it, which might render the object less an ideal mirror of the subject than a prosthetic support that this subject needs, desires, fetishizes (more on which in Chapter 7).

41. This is one reason why psychoanalysis might reinforce rather than reveal the inflation of the imaginary in visual culture. See Krauss, "Welcome to the Cultural Revolution," *October* 77 (Summer 1996).

42. See Mitchell, "What Do Pictures *Really* Want?". One might say the same thing about other human qualities projected on to images. For example, after a conversation with Benjamin on aura, Brecht dismissed it in his journal as "a load of mysticism" (25 July 1938; *Journals 1934–1955*, ed. John Willett, trans. Hugh Rorrison [New York: Routledge, 1996], p. 10). For a history of such projection see David Freedberg, *The Power of Images* (Chicago: University of Chicago Press, 1989).

43. Karl Marx, *Capital*, vol. 1, trans. Ben Fowkes (New York: Vintage Books, 1977), p. 165.

44. See the extraordinary genealogy of fetishism in William Pietz, "The Problem of the Fetish," *Res* 9, 13, 16 (1986–88), as well as my "The Art of Fetishism," in Emily Apter and William Pietz, eds, *Fetishism as Cultural Discourse* (Ithaca: Cornell University Press, 1993). For a related logic in American literature regarding the possessive white subject – that its presence required the supportive nonpresence of the black slave – see Toni Morrison, *Playing in the Dark* (New York: Random House, 1993).

45. Charles de Brosses, *Du culte des dieux fétiches* (Geneva, 1760); Immanuel Kant, "What Is Enlightenment?," in David Simpson, ed., *German Aesthetic*

and Literary Criticism (Cambridge: Cambridge University Press, 1984), pp. 29–34.

46. Georges Bataille, "L'Esprit moderne et le jeu des transpositions," *Documents* 8 (1930).

47. In this regard consider the language of the electronic revolution of the 1980s and 1990s – all the hallucinogenic and aleatory tropes in which virtual reality and the Internet were first presented to us. The exploration of the Information Highway was promised as the exploration of the mind, and in "the era of computerism" a principal frontier of capitalism remains the unconscious.

7 ART CRITICS IN EXTREMIS

1. Amy Newman, *Challenging Art: Artforum 1962–74* (New York: SoHo Press, 2000). Unless otherwise specified, all quotations are from this source.

2. The most succinct formulation is this of Donald Judd in 1964: "I'm totally uninterested in European art and I think it's over with" (Bruce Glaser, "Questions to Stella and Judd," in Gregory Battcock, ed., *Minimal Art* [New York: Dutton, 1968], p. 154).

3. Clement Greenberg, "Modernist Painting," *Art and Literature* 4 (Spring 1965), p. 199.

4. Greenberg, *The Collected Essays and Criticism*, ed. John O'Brian (Chicago: University of Chicago Press, 1986), vol. 1.; *Partisan Review* 7 (July–August 1940), p. 310.

5. On this dialectic see Chapter 5. Steinberg makes this connection in *Other Criteria* (New York: Oxford University Press, 1972).

6. Michael Fried, *Three American Painters: Kenneth Noland, Jules Olitski, Frank Stella* (Cambridge: Fogg Art Museum, 1965), reprinted in *Art and Objecthood* (Chicago: University of Chicago Press, 1998), p. 219.

7. See Tom Wolfe, *The Painted Word* (New York: Farrar, Straus & Giroux, 1975). Criticism can sometimes serve as a placeholder for artistic ambition at a time of artistic decline – clearly this is how Greenberg saw much of his later writing – which is hardly the same as a "painted word." Criticism

can also become an essential form in its own right. To a new generation of young artists and critics in the 1970s, the writing of Roland Barthes, Michel Foucault, and others seemed more vital – certainly more significant – than most contemporaneous art.

8. See Robert Morris, "Some Notes on the Phenomenology of Making: The Search for the Motivated" (1970), in *Continuous Project Altered Daily* (Cambridge: MIT Press, 1993).

9. Fried, *Art and Objecthood*, p. 101.

10. Thomas Crow, in Hal Foster, ed., *Discussions in Contemporary Culture* (New York: New Press, 1987), p. 7. Again, one notes a displacement of the political on to the aesthetic.

11. Theodor Adorno, *Aesthetic Theory*, trans. Robert Hullot-Kentor (Minneapolis: University of Minnesota Press, 1997), p. 1.

8 THIS FUNERAL IS FOR THE WRONG CORPSE

1. Heinrich Wölfflin, *Principles of Art History* (1915), trans. M. D. Hottinger (New York: Dover, 1950), p. ix (this remark dates from 1922). Two points of clarification. First, this is a question only of the end of art as an index to history, and here expectations were set too high to begin with. And, second, art might continue to represent contemporaneity in some quarters, but it does not define it.

2. Donald Judd, "Specific Objects," in *Complete Writings* (New York and Halifax: The Press of the Nova Scotia School of Art and Design, 1974), p. 184. See Joseph Kosuth, "Art and Philosophy I and II," *Studio International* (October and November 1969). Also see Thierry de Duve, "The Monochrome and the Blank Canvas," in *Kant after Duchamp* (Cambridge: MIT Press, 1996), and Rosalind Krauss, *A Voyage on the North Sea* (London: Thames & Hudson, 1999).

3. See, among other texts, Arthur Danto, *Philosophical Disenfranchisement of Art* (New York: Columbia University Press, 1986), and *After the End of Art* (Princeton: Princeton University Press, 1997). The first title might be more accurately rendered "artistic reenfranchisement of philosophy." The breakdown of a formalist modernism prompted end-of-art theses in the

1960s and the advent of a posthistorical postmodernism furthered them in the 1980s.

4. See Victor Burgin, *The End of Art Theory: Criticism and Postmodernity* (Atlantic Highlands, NJ: Humanities Press International, 1986), and Fredric Jameson, *Postmodernism or The Cultural Logic of Late Capitalism* (Durham: Duke University Press, 1991) and *The Cultural Turn* (London: Verso, 1998). Jameson surveys end-of-art theses in *The Cultural Turn*, and Perry Anderson surveys end-of-history theses in *A Zone of Engagement* (London: Verso, 1992).

5. See Rosalind Krauss, "Sculpture in the Expanded Field," in Hal Foster, ed., *The Anti-Aesthetic: Essays on Postmodern Culture* (New York: New Press, 1983).

6. Guy Debord, *The Society of the Spectacle*, trans. Donald Nicholson-Smith (Cambridge: Zone Press, 1994), p. 136.

7. See Benjamin Buchloh, *Neo-Avantgarde and Culture Industry* (Cambridge: MIT Press, 2000), and Hal Foster, *The Return of the Real* (Cambridge: MIT Press, 1996).

8. Theodor Adorno, *Negative Dialectics*, trans. E. B. Ashton (New York: Continuum, 1973), p. 3.

9. Karl Marx, 'Theses on Feuerbach,' in *The German Ideology* (New York: International Publishers, 1978), p. 123. "Perhaps," Adorno comments, "it was an inadequate interpretation which promised that it would be put into practice" (*Negative Dialectics*, p. 3).

10. Stan Douglas quoted in Scott Watson *et al.*, *Stan Douglas* (London: Phaidon Press, 1998), p. 28.

11. More precisely, the formal device from past art (e.g., the use of the enigmatic image of the body-part by way of Duchamp and Surrealism) inflects contemporary politics of race and sexuality, and vice versa.

12. See Harold Bloom, *The Anxiety of Influence: A Theory of Poetry* (New York: Oxford University Press, 1973). I borrow the phrase "ecstasy of influence" from my Princeton colleague Elaine Showalter.

13. There are many different moods of this shadowing. In *The Names* (1982) Don DeLillo has a character remark: "If I were a writer . . . how I would enjoy hearing that the novel is dead. How liberating, to work in the margins, outside a central perception. You are the ghost of literature.

Lovely." "I felt, at the same time," W. G. Sebald writes of a similar condition in *The Rings of Saturn* (1995), "both utterly liberated and deeply despondent" (see note 27).

14. Jacques Derrida, *Specters of Marx*, trans. Peggy Kamuf (New York: Routledge, 1994), pp. 10, 37. Only a generation ago the master thinkers of modernity – Marx, Freud, and Nietzsche – were returned to the present to radical effects – by Althusser, Lacan, Derrida, Foucault, Deleuze, and others. Today, after the supposed end of Marxism, the attacks on Freud, and the exposés of Nietzsche, these figures live on far more spectrally, and they are often disguised in self-defeating ways (e.g., Marx rewritten as a philosopher, Freud as a literary critic). These shades don't seem to haunt much or many anymore, and intellectuals now focus on "traces" and "vestiges." In *Twilight of the Gods* Nietzsche wrote of the influence of "posthumous men"; have we become post-posthumous?

15. Jon Bird in James Lingwood, ed., *House* (London: Phaidon Press and Artangel Trust, 1995).

16. Ibid.

17. The classic text on the nonsynchronous is Ernst Bloch, "Non-Contemporaneity and Obligation to its Dialectic" (1932), in *Heritage of Our Times*, trans. Neville and Stephen Paice (Berkeley: University of California Press, 1991). Rosalind Krauss has elucidated the role of the outmoded in Coleman and Kentridge in "'. . . And Then Turn Away?'," *October* 81 (Summer 1997), "Reinventing the Medium," *Critical Inquiry* (Winter 1999), and "'The Rock': William Kentridge's Drawings for Projection," *October* 92 (Spring 2000). All these practices demonstrate that new mediums are not necessarily techno-futuristic and anti-mnenomic – on the contrary.

18. Walter Benjamin, "Surrealism: The Last Snapshot of the European Intelligentsia," in *Reflections*, trans. Edmund Jephcott (New York: Harcourt Brace Jovanovich, 1978), pp. 181–82. I discuss this passage in *Compulsive Beauty* (Cambridge: MIT Press, 1993).

19. Benjamin, "Paris, Capital of the Nineteenth Century," in ibid., p. 161.

20. This position is distinct from the modernist melancholia of a Godard or a Wenders about the "death of cinema"; it seeks to mobilize this "death."

21. Stan Douglas quoted in *Stan Douglas*, p. 116.

22. Scott Watson, "Against the Habitual," in *Stan Douglas*, p. 46. Watson underscores the influence of the topos of habit not only in Proust but in Samuel Beckett on Proust (in his short 1931 text *Proust*).

23. Douglas quoted in ibid., pp. 9, 29.

24. Jimmie Durham quoted in Laura Mulvey *et al.*, eds, *Jimmie Durham* (London: Phaidon Press, 1995). These artists suggest an artistic equivalent of the "minor literature" defined by Deleuze and Guattari in their 1975 study *Kafka: Toward a Minor Literature*, trans. Dana Polan (Minneapolis: University of Minnesota Press, 1986): "The three characteristics of minor literature are the deterritorialization of language, the connection of the individual and the political, the collective arrangement of utterance."

25. See Benjamin Buchloh, "The Sculpture of Everyday Life," in Alma Ruiz, ed., *Gabriel Orozco* (Los Angeles: Museum of Contemporary Art, 2000).

26. See Molly Nesbit, "The Tempest," in ibid.

27. One last version of aftermath to mention here is not so sanguine. W. G. Sebald has offered his own term for the structure of feeling within this condition: "vertigo" [*Schwindel*] in his 1990 novel of that name. This is the mental state of life "amidst the remains of our own civilization after its extinction," as he puts it in *The Rings of Saturn* (1995). It is a melancholia that, paradoxically, is detached from its lost object – because there are too many lost objects to track, so many that it makes one vertiginous (again: "I felt, at the same time, both utterly liberated and deeply despondent"). In a sense the vertiginous is a combination of the nonsynchronous and the incongruent, of displacements or disorientations in both time and space; and Sebald's narratives at once enact this vertigo and seek to survive it. Like Gerhard Richter in his *Atlas*, a compendium of photographs, private and public, Sebald constructs his work out of archives of personal pasts vectored by public pasts. The result is an unnamable genre that is both fictional and nonfictional, that lives beyond these genres just as premodern texts lived before them. Of special interest here is his use of banal photographs and old traces of travels as in Surrealist novels (e.g., train tickets, hotel receipts, journal entries) – all as indexical markers to ground his excursions into history, literature, and fantasy. Yet – and this is key to the vertigo of coming-after – these indices are as "anomic" as they are "mnemonic." They enact the dialectic between

the two terms that Benjamin Buchloh also finds in the Richter *Atlas*, in which the two share in each other, in which (for example) the photographic is ambiguously both (see Chapter 5, note 26). As Sebald puts it in *The Emigrants* (1992), in a paradox crucial to vertigo, "and the last remnants memory destroys." This destruction is never total, or rather memory is sometimes enabled by this destruction: "Whenever a shift in our spiritual life occurs and fragments such as these surface," he writes in *The Rings*, "we believe we can remember." But this is quickly qualified: "In reality, of course, memory fails us. Too many buildings have fallen down, too much rubble has been heaped up, the moraines and deposits are insuperable."

INDEX

Note: page references in italics indicate illustrations.